Flashing on the Sixties

Flashing on the Sixties

Photographs by Lisa Law

CHRONICLE BOOKS • SAN FRANCISCO

Printed in Japan

Library of Congress Cataloging in Publication Data
Law, Lisa.
 Flashing on the sixties / Lisa Law.
 p. cm.
 ISBN 0-87701-465-5 (pbk.)
 1. United States—Popular culture—History—20th century—
Pictorial works. 2. United States—Social life and customs—1945–
1970—Pictorial works. 3. United States—History—1961–1969—
Pictorial works. 4. Photography, Documentary—United States. I. Title
E169.12.L35 1987 87-16477
973.92′022′2—dc19 CIP

Editing: Barabara Youngblood
Book and cover design: Ed Marquand Book Design
Composition: The Type Gallery

Cover: The Grateful Dead, the Human Be-In, 1967
Back cover: Bonnie Jean (Jahanara) Romney

Photographic enlargements by
Isgo Lepejian B & W Photo Lab
3108 West Magnolia Boulevard
Burbank, CA 91505

Distributed in Canada by
Raincoast Books
112 East 3rd Avenue
Vancouver, B.C.
V5T 1C8

10 9 8 7 6 5 4 3 2

Chronicle Books
San Francisco, California

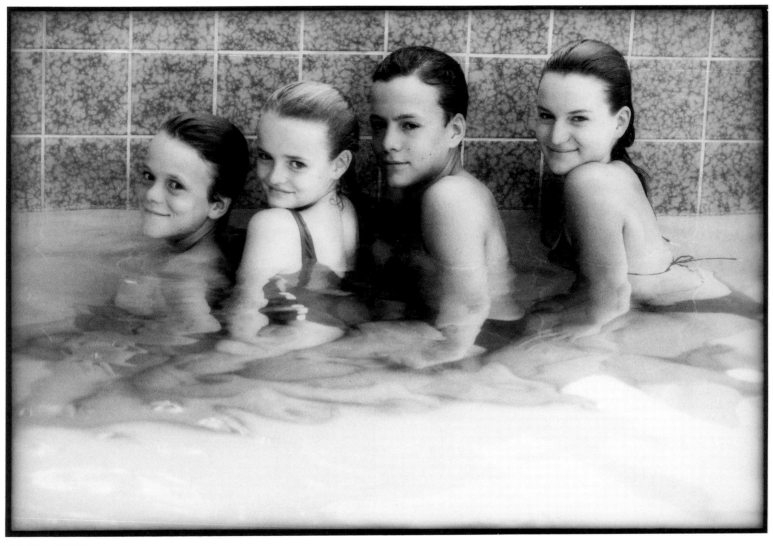

Malibu, 1985

This book is dedicated to my children, Jesse Lee Rainbow, Sunday Peaches, Solar Sat Baba, and Dhana Pilár, for their constant inspiration and love, and to my cameras, without which all of this would be out of focus by now, and to the memory of my father, Lee Bachelis, and our dear friends, John Brent, Lew Welch, Frank Oppenheimer, and to the American soldiers in Vietnam.

Thank you Frank Werber for giving me my first professional camera.

*I'm a farmer. I don't know how to speak to twenty
people at one time let alone to a crowd like this. This is the
largest group of people ever assembled in one place . . . but I
think you people have proven something to the world . . .
that a half a million kids can get together and have three
days of fun and music and have nothing but fun and music
and I God-Bless-You for it.*

Max Yasgur, Woodstock, 1969

Foreword

These photographs are nostalgia, pure and simple: memories of a time of Divine Funk. Yet they chronicle a moment in history when there was a mushroom explosion of consciousness and a resulting increase in life force. And through that explosion we broke out of the prison created by the worship of our intellect. As we went out of our minds, we met once again our own innocence. We rejoined the Universe—a Universe no longer separated from us by the chasm of dualistic thought. And freeing ourselves of the rational mind as ultimate arbiter of reality freed us simultaneously of the constrictions of Puritan values and the Protestant work ethic. We had opened once again the cookie jar of possibilities—political, social, sexual, and spiritual. It was all up for grabs.

What caused it? Who knows! Perhaps it was psychedelics, or what TV and jet travel and Einstein did to our concepts of time and space, or the Damocles sword of nuclear annihilation hanging over our heads, or all or none of the above. Whatever it was, it worked. It was Grace which allowed us once again to taste, touch, feel, and dwell in our own divinity. Life regained its cosmic proportions as a dance, as a delightful play.

Poets, clowns, musicians, yogis, women political activists, minority groups, sexyfolk both straight and gay, esoteric religious practitioners, entrepeneurs, single parents, healers, and folks involved in birthing and dying were all suddenly free to BE. We recognized, as C. S. Lewis had pointed out, that you can't see the center because it's all center, and that each of us is a superstar creating our own universe.

Perhaps we could hold this pure space in its fullness for only a moment before our karmic veils once again descended. But those of us who were there will not forget. And the effects of that explosion in the sixties have by now permeated every nook and cranny of our culture.

History is too often the story of battles, power struggles, and death. As Lisa Law demonstrates in this book of images, however, her story is one of birth.

Baba Ram Dass

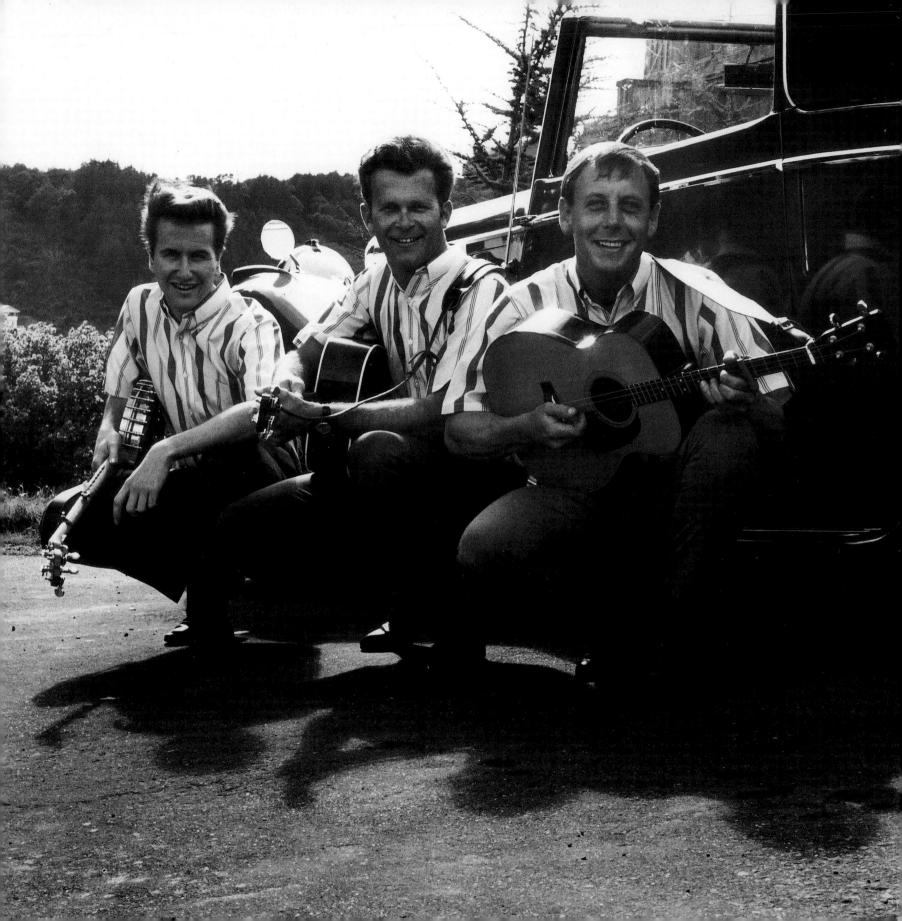

Growing up in Burbank was great. I learned to ride a horse almost before I could walk. As a teenager, I rode nearly every day after school. On hot afternoons I'd be horse-knee high in the water of the pollywog pond or belly down in the shallow water talking to the frogs.

At eighteen I joined a six-member crew to spend ten years sailing around the world on the Fairweather, a fifty-seven-foot gaff-rigged schooner, and bailed out in Acapulco after three months, but not before I had fallen in love with the sea, the schooner, Mexico, and its people.

My dad, Lee, loved to take 16mm movies of his fishing and wild-boar hunting trips to Guaymas, Mexico. Maybe that's where I got my taste for photography.

I had an Instamatic camera and never considered getting a better one until my friend Frank Werber gave me a Leica. Frank was manager of The Kingston Trio, and I worked for him, taking care of his grocery shopping, housecleaning, cooking, car (a white Cadillac convertible with a phone), motorcycle, and yacht. There I was, with my new camera, in the middle of the music business scene, groups everywhere and pictures needing to be taken. So after one course in photography at College of Marin, I started shooting—The Kingston Trio, We Five, Paul Horn, The Beatles, Sonny and Cher, The Lovin' Spoonful, The Byrds, and anyone else I could focus my lens on. A Nikon F was my second camera.

I was twenty-two and daring and went wherever the moment took me. The music scene was starting to happen. Elvis had got the hips moving and minds racing, and a movement was being born. Everything seemed to happen at once. The war in Vietnam was escalating, Martin Luther King, Jr., was leading the fight for civil rights, people were dropping acid as often as the pill, and music was expressing it all.

The Kingston Trio posing for an album cover,
Mill Valley, California, 1965

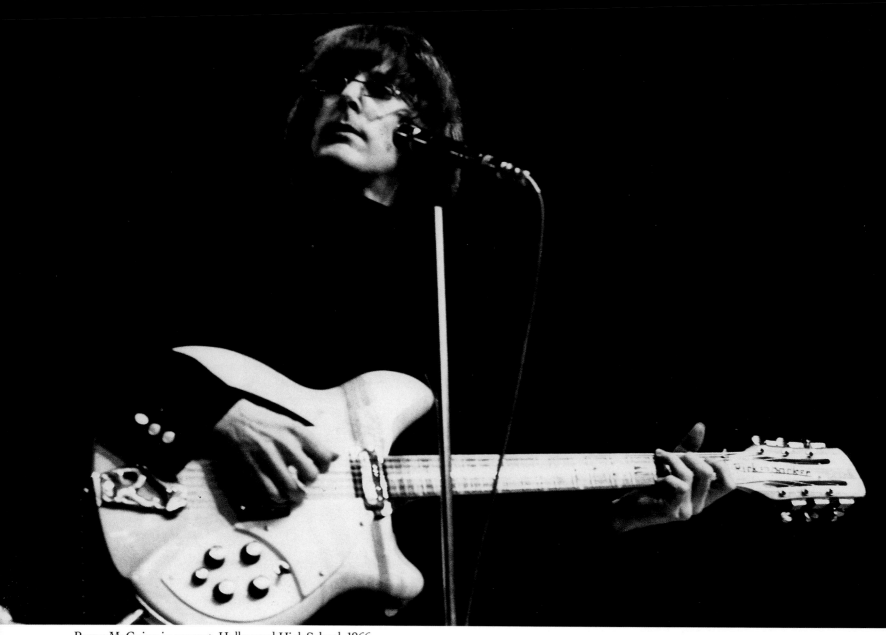

Roger McGuinn in concert, Hollywood High School, 1966

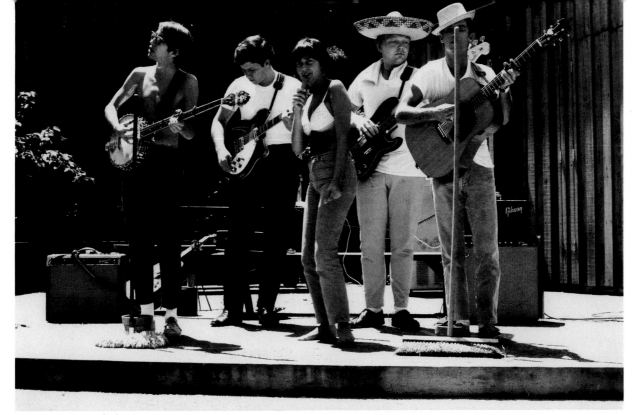

We Five rehearsing at Frank Werber's house, Mill Valley, California, 1965

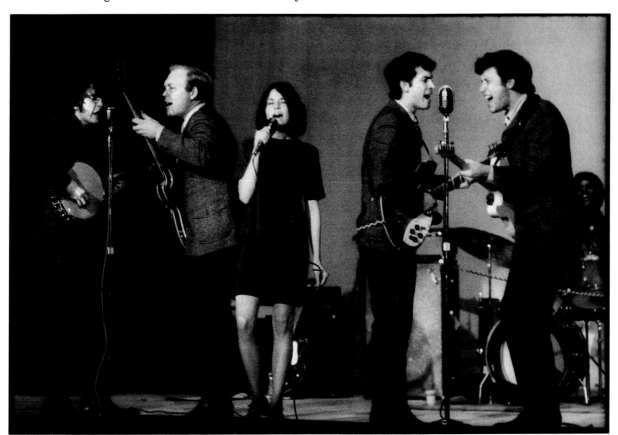

We Five in concert, San Francisco, 1965

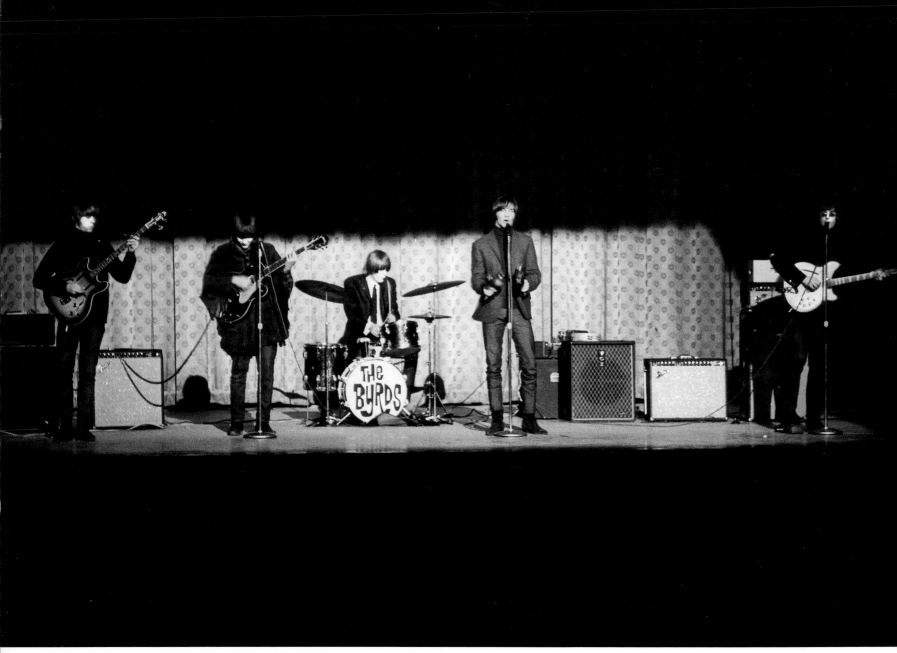

The Byrds in concert, Hollywood High School, 1966

The Byrds were ex-folkies. McGuinn was backing the Limelighters as the guitar player. Gene was with the New Christy Minstrels, and I was with the Les Baxter's Balladeers so I could pay the rent. And then we saw A Hard Day's Night and somebody said, "I wanna hold your hand," and I said, "Yea, that's it, that's it!" We all flipped out. "That's what we want to be." And we all got electric guitars, and that was the Byrds. Bingo Pow!

I was with the Byrds until '67, and then they threw me out. They said, "You're absolutely impossible to work with, and we'll do better without you." So, we made up

Crosby, Stills and Nash. Stephen had Buffalo Springfield fall apart around his ears, and Nash had the same problem with the Hollies. We had been trying to repeat our old formulas but C.S. & N. didn't want to do that, we wanted to play exciting music, something fresh. The beginning of 1969 we put the band together, and the first time we played was Chicago Auditorium Theater. The second time we played was Woodstock.

David Crosby

Music was the great unifier. Instead of doing the fox-trot, where you went around in a little box, people started dancing free-form. It was Dylan, The Grateful Dead, The Jefferson Airplane, Joan Baez, The Beatles. Getting stoned and listening to The Beatles woke up a lot of people. Look at the lyrics. They went from "I wanna hold your hand" to "I want to turn you on." There's one line in "Hey Jude" that sort of sums up what that period was about: "Take a sad song and make it better." That said a lot about what the human condition is and what can be done about it. So they were an inspiration to a lot of people. When I had my radio show, I asked people to call in and tell me what it was in their lives that kind of woke them up. And more than a few said getting stoned and hearing The Beatles. It was an awakening on a mass level, and that's what it was about. It was like some kind of fairy story, people waking up.

Paul Krassner

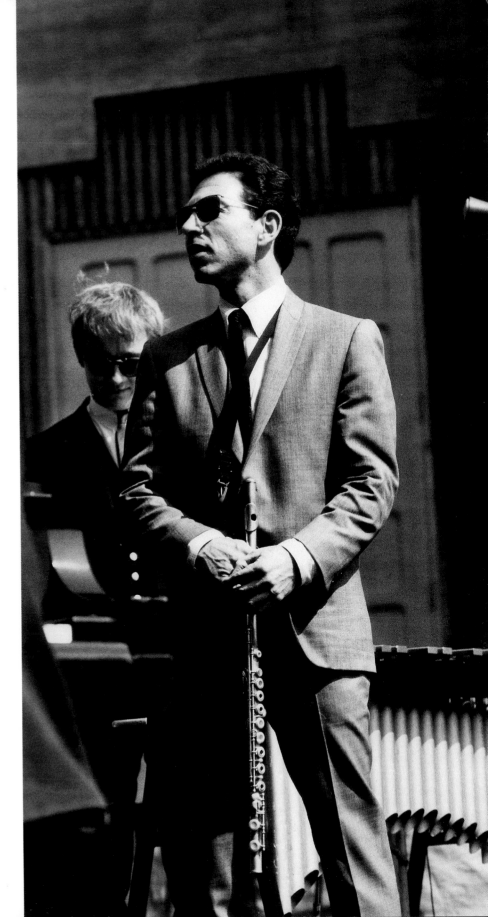

Paul Horn, Pilgrimage Theatre, Los Angeles, 1965

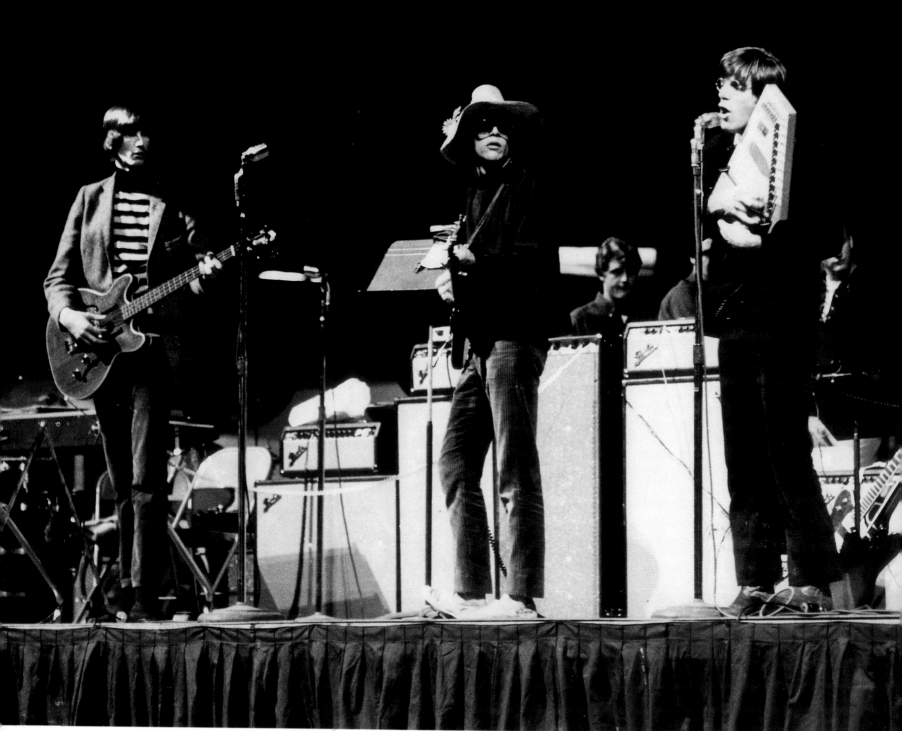

The Lovin' Spoonful in concert, Cow Palace,
San Francisco, 1965

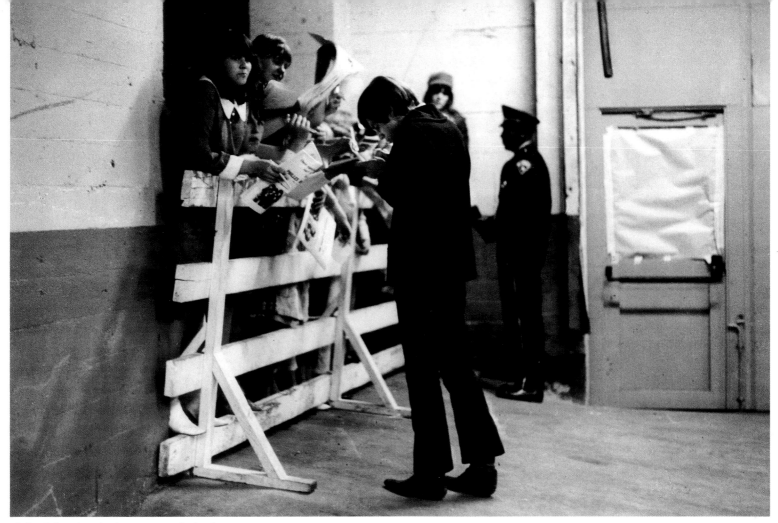

John Sebastian signing autographs backstage,
Cow Palace, San Francisco, 1965

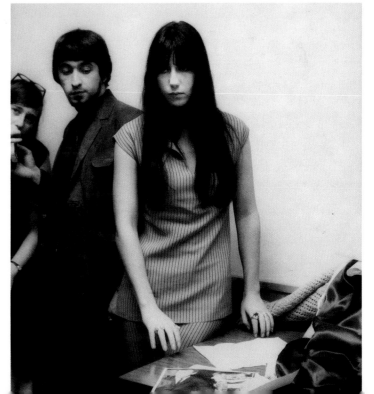

Cher Bono backstage at a Cow Palace concert, San Francisco, 1965

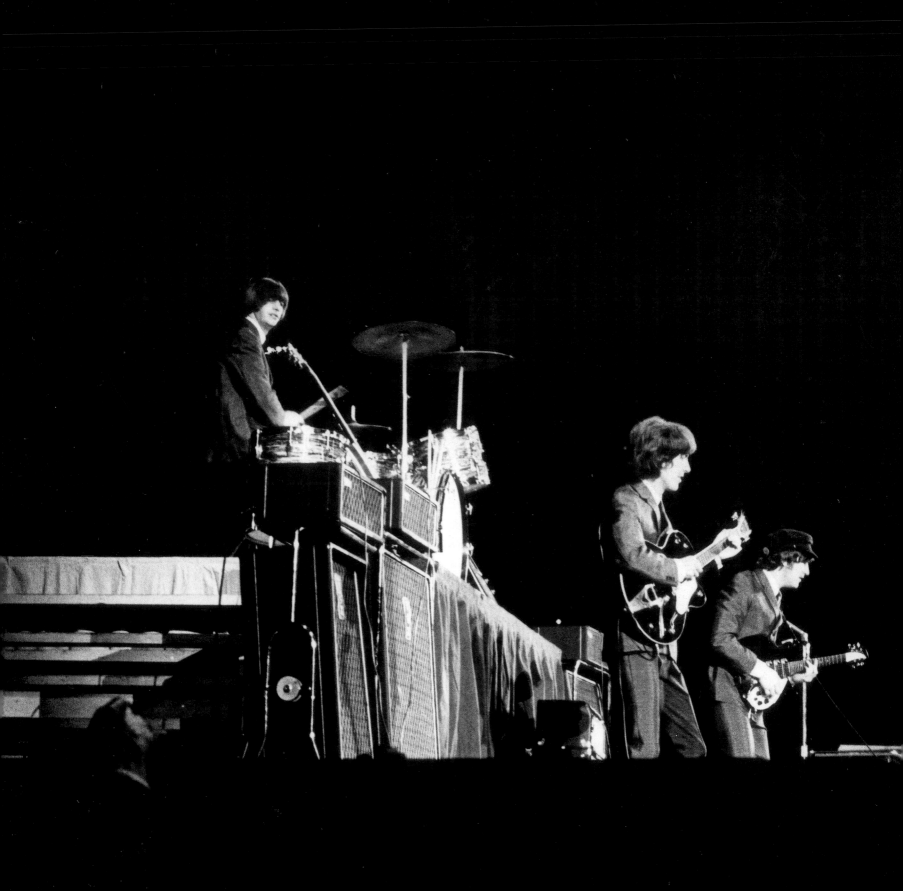

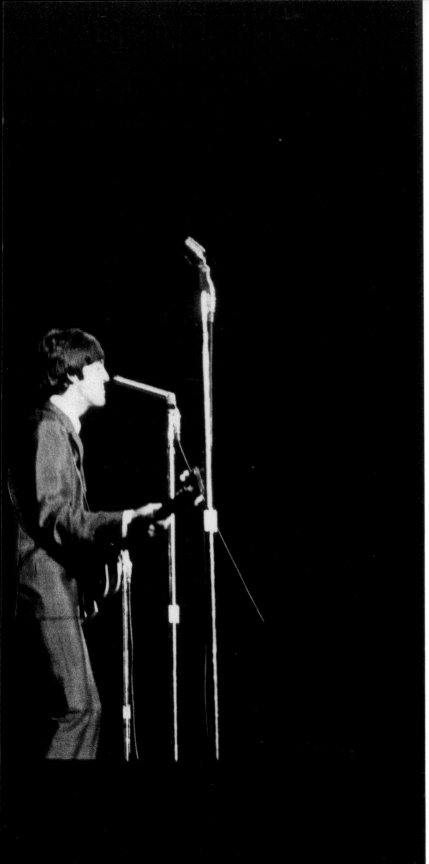

went to The Beatles concert at the Cow Palace in San Francisco in 1965 with Jon Sagan, a record producer with Trident Productions (Frank Werber's label). Jon had backstage passes. I was able to shoot right in front of the stage. Behind me police officers were holding hands to keep the people back. Teenagers filled every seat. Every time The Beatles started to sing the audience screamed so loud I could barely hear the words. The crowd was so immense the promoters had to put up barricades to keep the fans away from the stage. The girls who managed to get over the barricades became so hysterical they either fainted or wept and had to be dragged off.

When the concert was over, John Lennon ran full speed backstage, carrying his guitar, passing Joan Baez, who was sitting on a speaker box, and disappeared into his trailer. Then all at once the four dashed into a waiting limousine and got away before the crowds found them.

The Beatles, Cow Palace, San Francisco, 1965

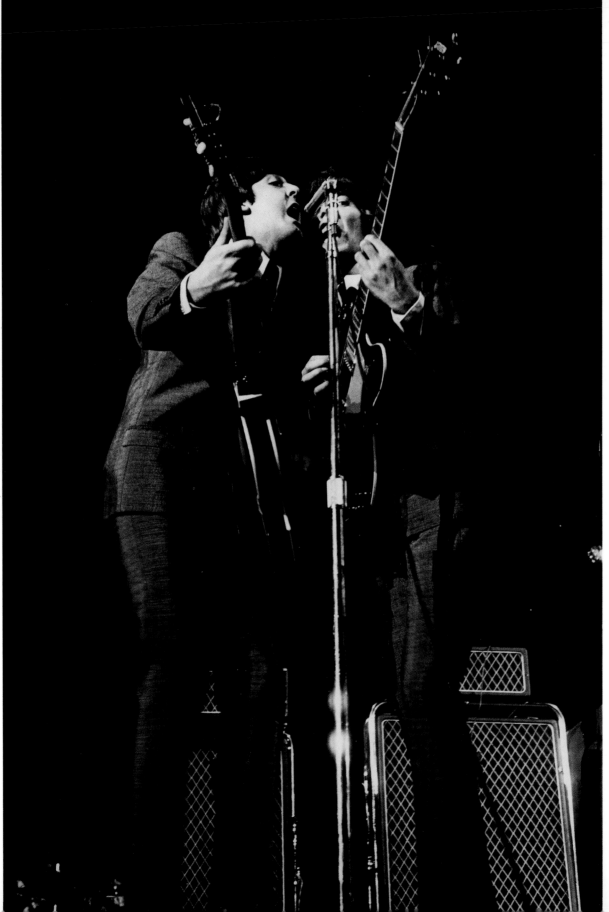

Paul McCartney and
George Harrison of
The Beatles, Cow Palace,
San Francisco, 1965

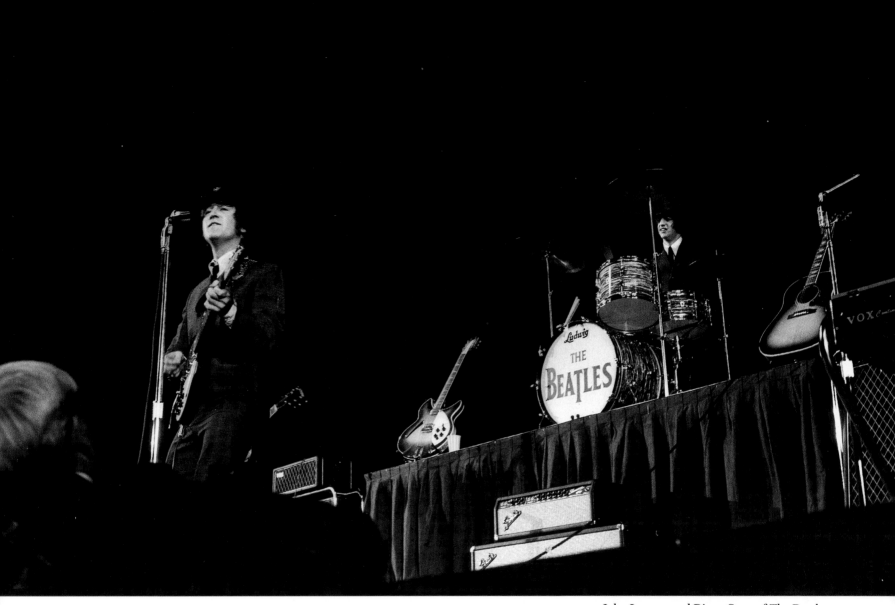

John Lennon and Ringo Starr of The Beatles,
Cow Palace, San Francisco, 1965

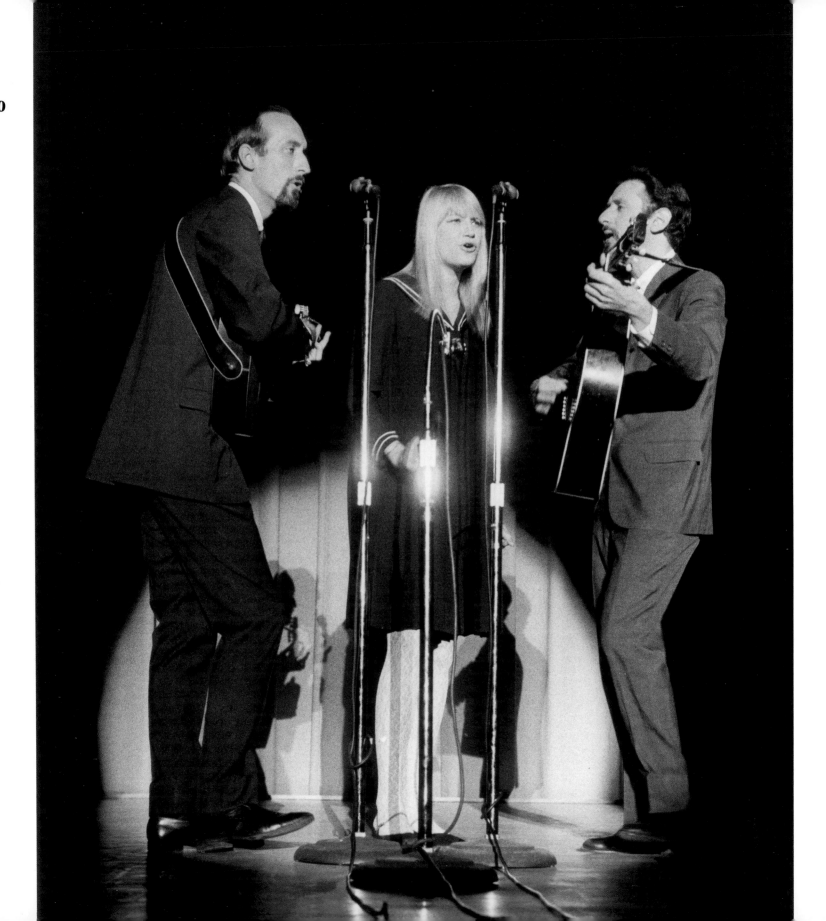

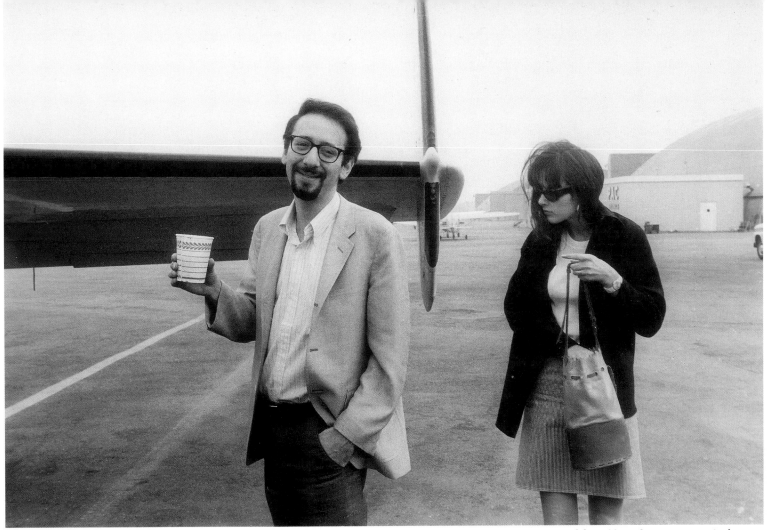

Peter Yarrow and friend boarding a private airplane on way to a concert, Burbank, 1965

rank Werber took me to a Peter, Paul and Mary concert in Berkeley in the spring of my twenty-second year. Backstage I ran into Eddie Sarkesian, their booking agent. As I was talking to him, I turned and saw Tom Law, Peter, Paul and Mary's road manager. My mouth dropped open. "Who is THAT!?" Eddie answered, "That's your husband." "I know," I said. "Introduce me." That night we ate wedding soup at Original Joe's in North Beach; the rest is history.

Tom worked for Albert Grossman, who managed both P P & M and Bob Dylan. A few months later he quit his road work and went to work for Mike Nichols, who was directing *Who's Afraid of Virginia Woolf?* in Los Angeles. Tom's job was assistant to the director. Soon after, he moved into The Castle.

Peter, Paul and Mary, 1965

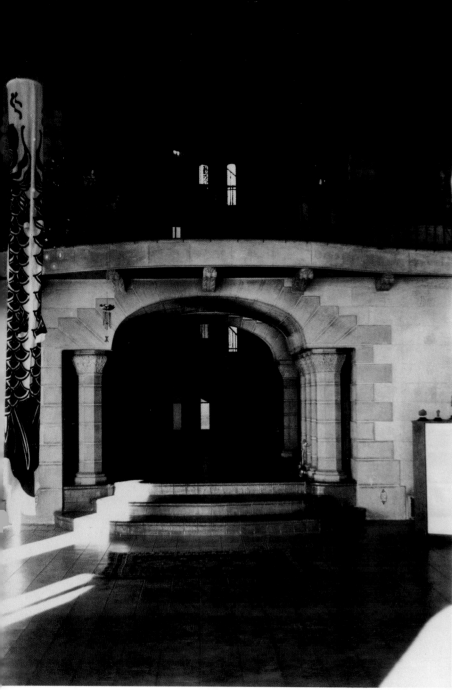

The Castle ballroom, 1966

In 1965, after Tom had courted me long-distance—Los Angeles to San Francisco—he asked me to move into The Castle, a four-story mansion in the Los Feliz Hills of Los Angeles which had just been purchased by Tom, his actor brother John Phillip Law, and a friend, Jack Simmons. I felt like a storybook princess having the run of such a grand place. The ballroom had a gold-leaf ceiling, and the kitchen table was ten feet long. The Castle sat on top of a three-acre piece of land with jade gardens, purple-flowered ice plants, and many trees. At the bottom of the garden was a pond where our goose lived. On top of the garage apartments, I kept a flock of homing pigeons that would fly in formation twice a day around the tower where Tom and I slept.

The entranceway, The Castle

View from the garden, The Castle, 1966

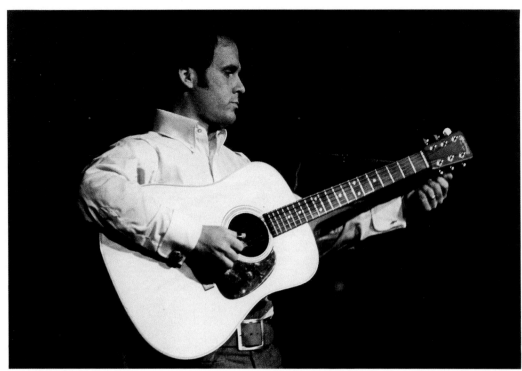

Tim Hardin, Los Angeles, 1967

Susan Hardin, Los Angeles, 1967

Nico, John Phillip Law's house, Hollywood, 1967

Patrick Close. He adopted us. We adopted him. The Castle, 1966

To help make the payments, we rented out suites. At various times our tenants included Severn Darden (actor from Second City and The Committee), Barry McGuire (of The New Christy Minstrels, who sang "The Eve of Destruction"), Bob Dylan, and Andy Warhol and The Velvet Underground.

I had gone from making and selling paper flowers in Sausalito to being the housemother—tidying up, doing the grocery shopping on a Triumph 650 motorcycle, making and serving food, gardening, gamekeeping, dancing wildly to The Beatles, and hiding the dope. (I was convinced we were about to be busted any second, although we never received a single visit from The Law.)

Perhaps because I was not a professional photographer and therefore not taken seriously by anyone, including myself, I was able to record some of the more relaxed moments from those days.

Tom Law, The Castle

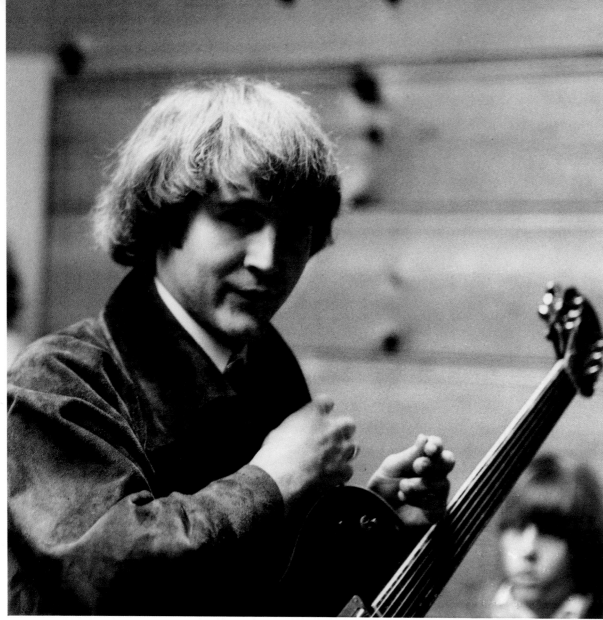

David Crosby, 1965

The Castle was the first place I ever heard the music of Bulgaria. I went in there one day in my usual fashion, ripped to the tits—I was just as high as I could get—and someone was playing the music of The Bulgarian National Folk Ensemble in Choir under the direction of Philippe Koutiv. That record taught me as much about harmony as The Everly Brothers, and that's saying something. I mean I studied it, I listened to it a thousand times . . . on acid . . . on everything . . . straight . . . asleep . . . awake . . . making love . . . many times. It's imprinted. I can sing you all those songs.

David Crosby

The Castle (Copa de Oro), Los Feliz, Los Angeles, 1966

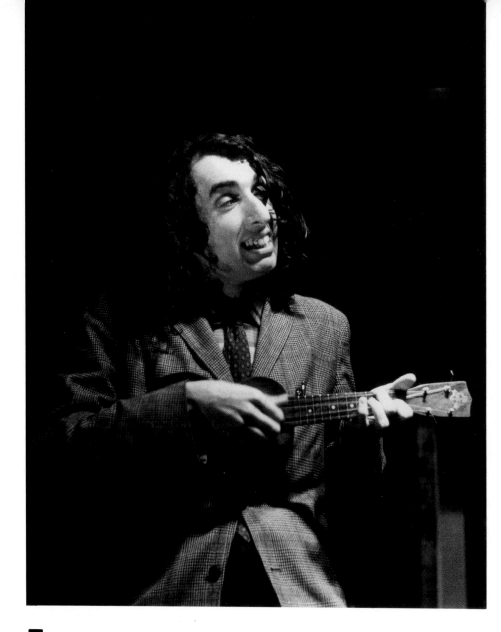

Tiny Tim was readily accepted by us more than by anyone else. If somebody was weird and almost inexplicable, we thought they were on top of things because they were doing more or less what they felt like doing.

Severn Darden

Tiny Tim, The Phantom Cabaret,
Los Angeles, 1966

Tiny Tim was performing with Severn Darden, Del Close, and Hugh Romney (aka Wavy Gravy) at The Phantom Cabaret. Wavy had decided to bring him to California from New York and make him famous, which he did.

He came to The Castle and sang "Tiptoe Through the Tulips" from the balcony overlooking the ballroom. He always carried a brown shopping bag with his ukulele in it, and if you were lucky he would pull it out and play a sweet tune. I also remember that he ate a lot of canned spinach and liked a private shower adjoining his room.

We called him Mr. Tim and treated him with enormous respect. But eventually Mr. Tim began to doubt himself and believe what his managers thought, that it was all an act.

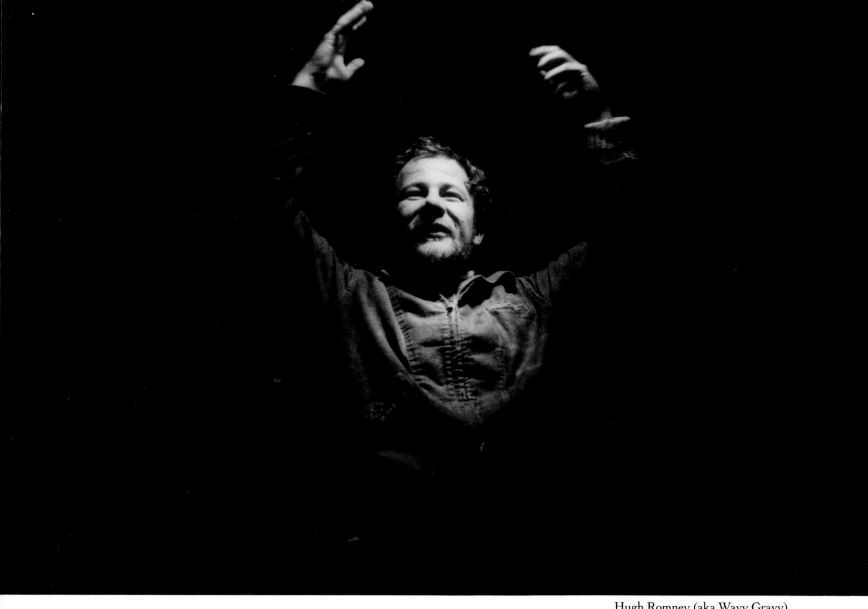

Hugh Romney (aka Wavy Gravy),
The Phantom Cabaret, Los Angeles, 1966

30

Dylan,
The Castle,
1966

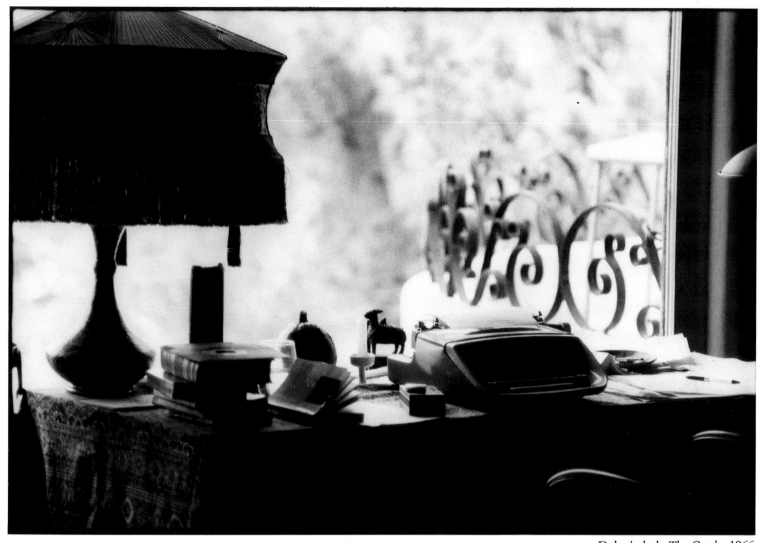

Dylan's desk, The Castle, 1966

When Dylan was home, he could be heard typing his lyrics long into the night. Chocolate milkshakes seemed to be his main staple. Earth Mother that I am, and a true believer in the need for a balanced diet, I would insist that he come down for meals. I especially liked to feed him horse-meat steak, which I purchased in fillet form at the local pet-food store, kasha, peas, and salad.

Occasionally, after a long writing session, I would massage his neck and back. This relaxed and sometimes annoyed him because it sent him to sleep and interfered with his working. Those were the times I felt close to Dylan. Though he didn't stop me from photographing him, I was never comfortable doing it. He had a stare that intimidated me and took my breath away.

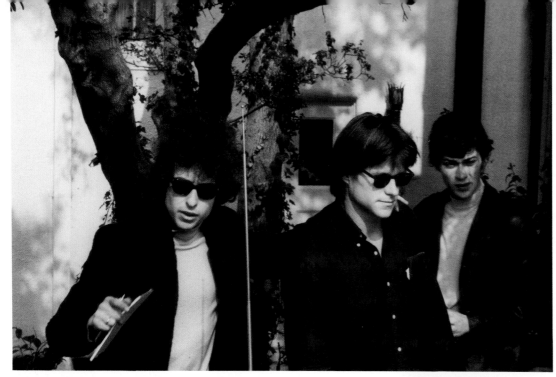

Above: Dylan, Tom Law, and Robbie Robertson
of The Band in front of The Castle, 1966.
Right: Victor Maymudes and Dylan at The Castle,
1966.

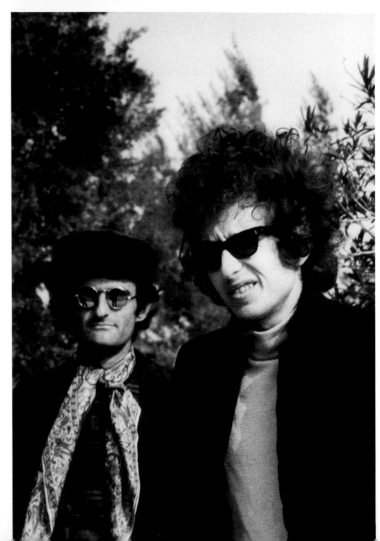

*The first time I saw Bob Dylan, he came wandering into
the Gaslight Cafe on MacDougal Street wearing Woody
Guthrie's underwear. I know that only in hindsight. Also
he had a sign on his guitar that said THIS MACHINE
KILLS FASCISTS. He asked me if it was all right if he per-
formed, and I said, "Well, there's a little lull. What's your
name, kid?" He said, "Bob Dylan," and I said, "Ladies and
gentlemen, here he is, a legend in his own lifetime. What's
your name again?"*

 *That was when he first came to the Village and started
hanging out. I had a room upstairs that we used to share.
He could talk really fast, and he also bounced his foot up
and down a lot. All the artists used to come up to that little
room, smoke some grass, hang out, and sing songs. There
was a lot more going on up in that little room sometimes
than there was in the Gaslight downstairs. "A Hard Rain's
Gonna Fall" was written up there on my typewriter.
Dylan and Hamilton (Bobby) Camp sang it together for the
first time up there; then Dylan went downstairs and sang it
for the audience. "Bob Dylan's Dream" on his Free-
wheelin' album is about that room over the Gaslight.*

 Wavy Gravy

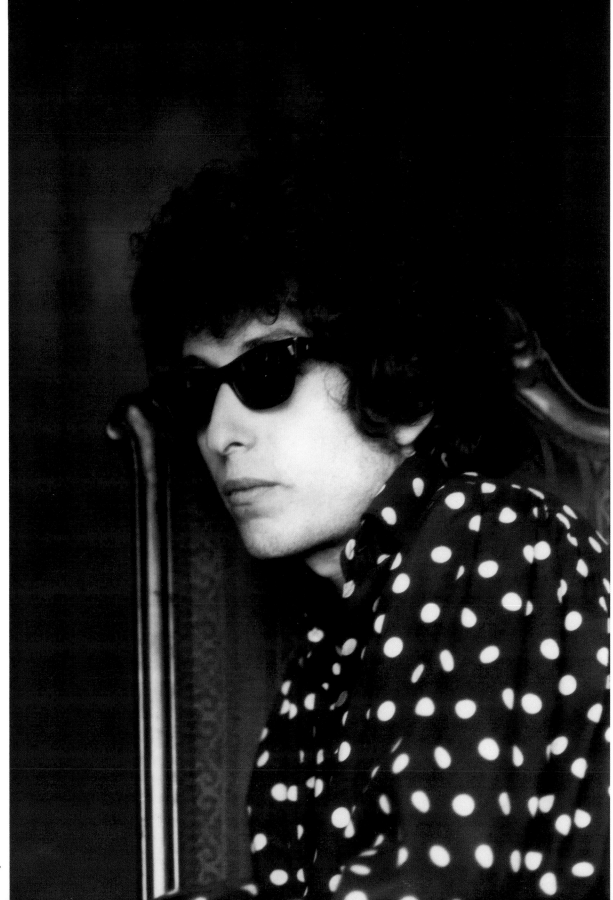

Bob Dylan at dining table,
The Castle, 1966

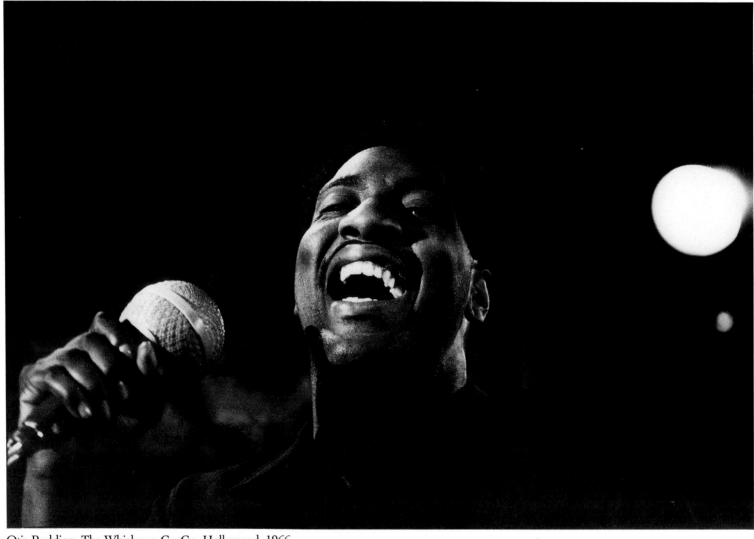

Otis Redding, The Whiskey a Go-Go, Hollywood, 1966

While Dylan was living at The Castle, Otis was the headliner at the Whiskey A Go-Go on the Sunset Strip. This was two years before he blew everyone's mind at the Monterey Pop Festival. Dylan, Tom, and I went to hear him. Otis was backed by a big band that had lots of horn players. They danced in unison behind him as he jumped around the stage. I stood right in front of the platform, mesmerized by this man's soul and power. He blew my mind.

Dylan went backstage after the show to meet Otis and ask him if he would sing one of his songs on his next album. I stood in the doorway digging watching, my heart pounding with the joy and excitement of that moment.

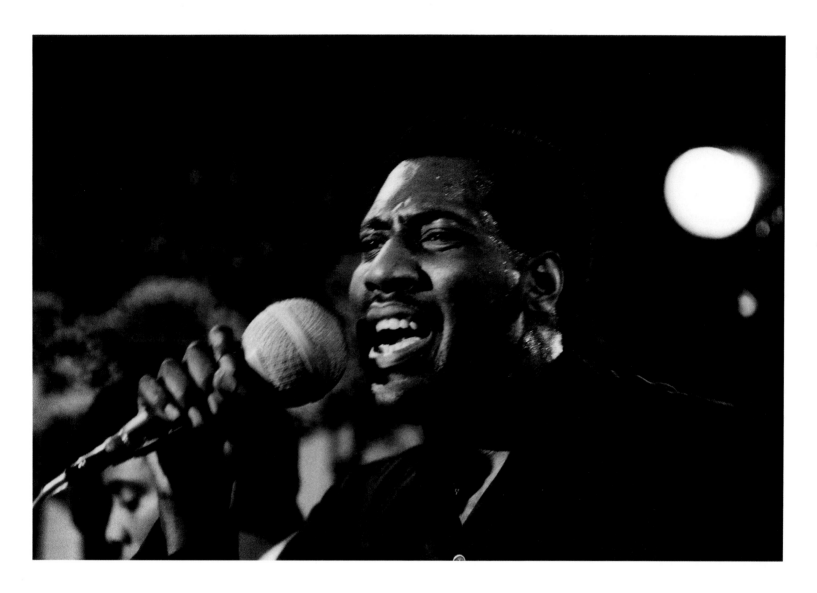

If you have been horsewhipped and stepped on for centuries, whoever wants to make you excited enough to bring you out of that had better do a real good job.

We opened every night for a week for Otis Redding at The Whiskey a Go-Go in 1966. I felt all the volcanoes and energy inside me when that man started playing. That got me excited. It was the first time somebody ever gave me a body back in music.

Taj Mahal

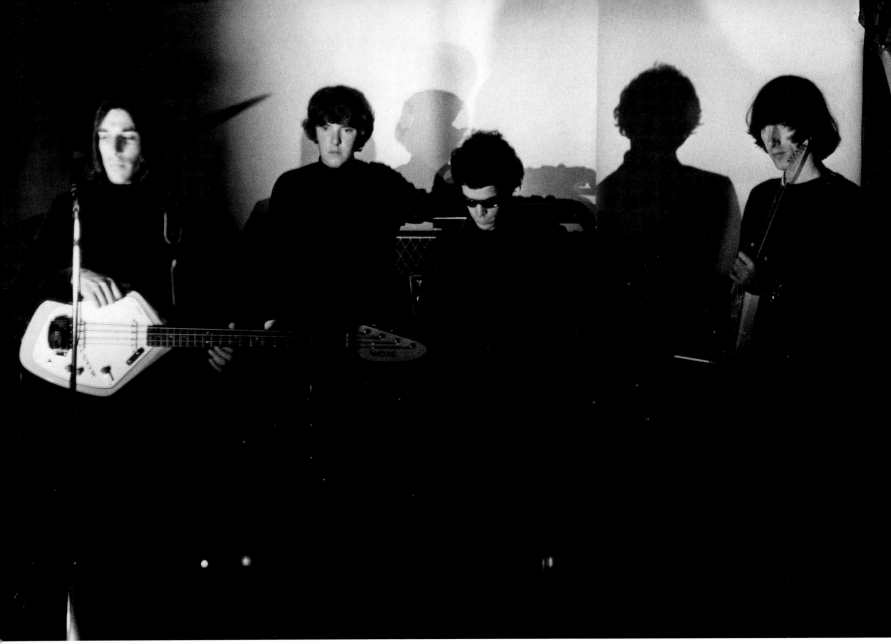

The Velvet Underground, The Trip, Hollywood, 1966

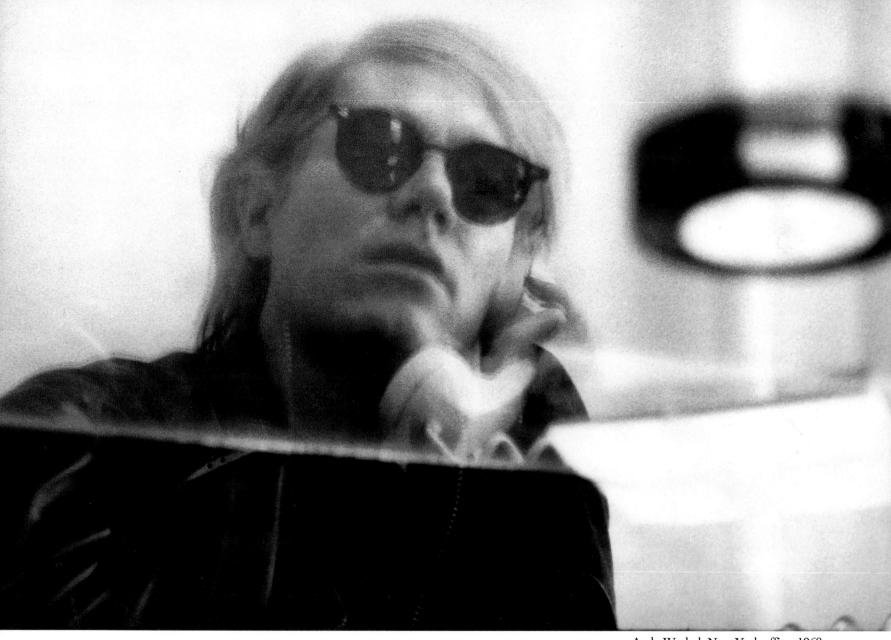

Andy Warhol, New York office, 1968

Andy Warhol and his group, The Velvet Underground, came
to do a gig at The Trip, a nightclub on the Sunset Strip
where the most interesting groups always played. They
wore black leather and used whips in their act. In spite
of this they were very nice people. Much later, on the
way to Woodstock, we stopped off in New York City to
sell Warhol some Danger Radiation signs we had bought
from the Los Alamos Research Center salvage yard.

When I met Andy, he showed me a rock that looked
like a rose. I liked him immediately.

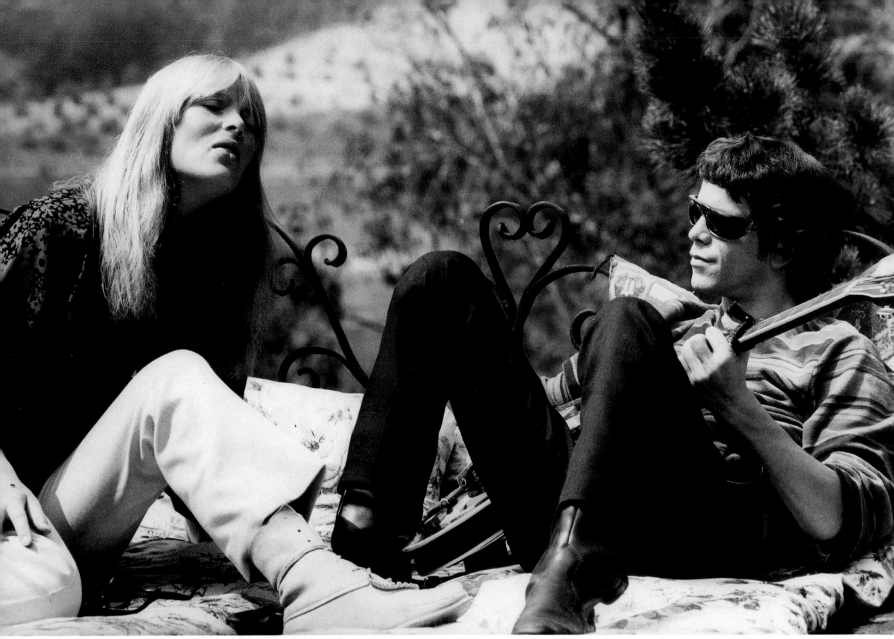

Nico and Lou Reed of The Velvet Underground
rehearsing on the patio of The Castle, 1966

Gerard Malanga,
The Velvet Underground,
The Trip, Hollywood, 1966

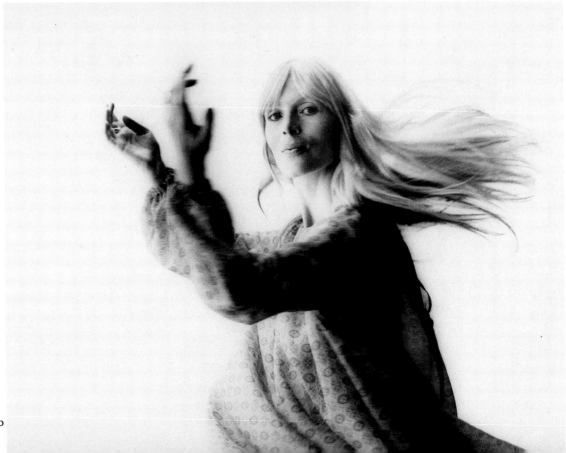

Nico

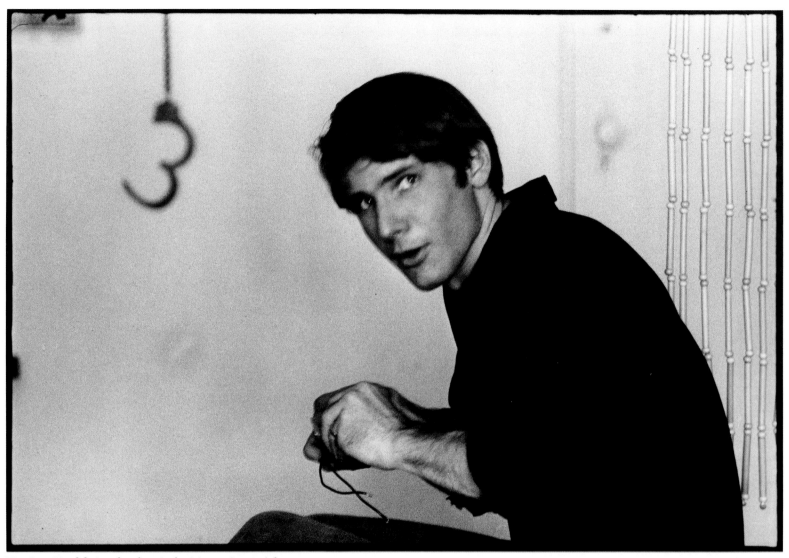

Harrison Ford fixing the electrical wiring at Severn's house.
He also was an expert cabinet maker.

n 1966 Tom and I dropped out for three months and went to Mexico, leaving The Castle to whoever could handle it (mainly Severn and Patrick). We had planned to build a palapa in Yelapa near Puerto Vallarta and live off the land and the sea, but both of us contracted hepatitis from bad water and had to return to Los Angeles to recuperate. Severn Darden took care of us, and when we got better we moved back to the Bay Area—Forest Knolls in Marin County. We camped in a small cabin in the woods and from there ventured out to see the world and the beginning of the Haight-Ashbury in San Francisco.

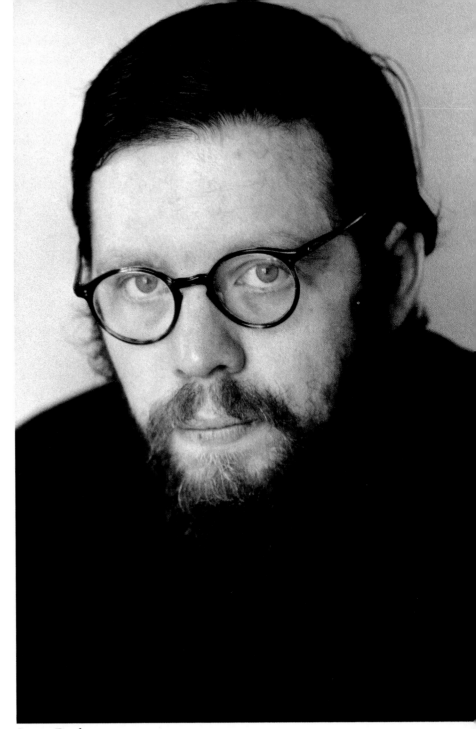

Severn Darden

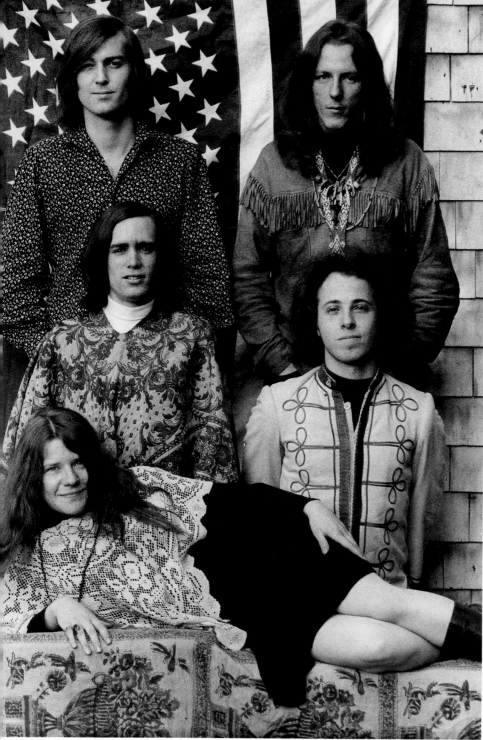

Janis was rehearsing with Big Brother and The Holding Company in a large wooden house at the end of a dirt road in Lagunitas, very close to where we lived in Forest Knolls. As I walked into the house, I was totally stunned by a voice belting out from another room. The power of her voice and the stomping of her foot shook the whole house.

Every time I hear "Get It While You Can" by Janis, it brings back a wonderful memory of her swinging those hips and skirts around the corner and me standing there and looking up and saying "Wow!" And I embraced her and she said, "Meet these guys. This is this great new band [Full Tilt Boogie] I've got." And I looked at all those wild-looking cats and their horns and saxophones and dark glasses and all this stuff and said, "Well, I'll be damned; she finally did it."

Then I went and heard the record and said, "Whoa, this is right on." But you know what I thought, they're not gonna let her do this. And, sure as shit, some of her management made a lot of bad decisions. The decisions were made visually and not in terms of the music or what was going to go down in history.

Taj Mahal

Janis Joplin and Big Brother and The Holding Company, Lagunitas, 1967

Janis Joplin, Woodacre, 1967

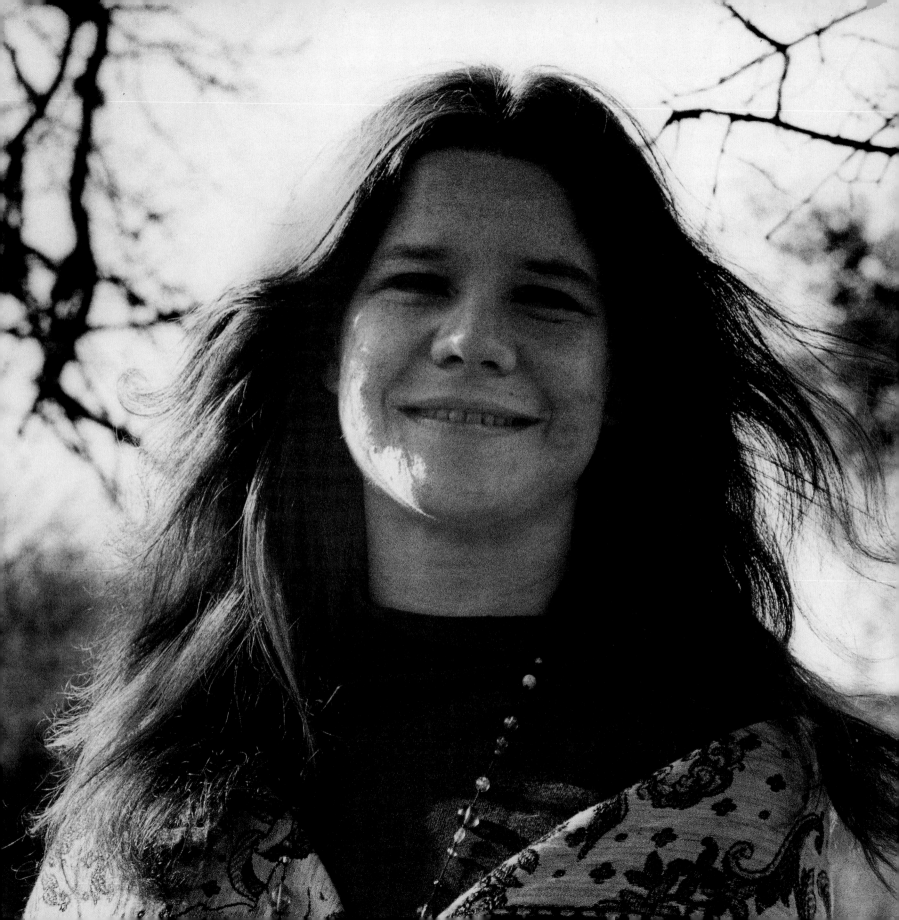

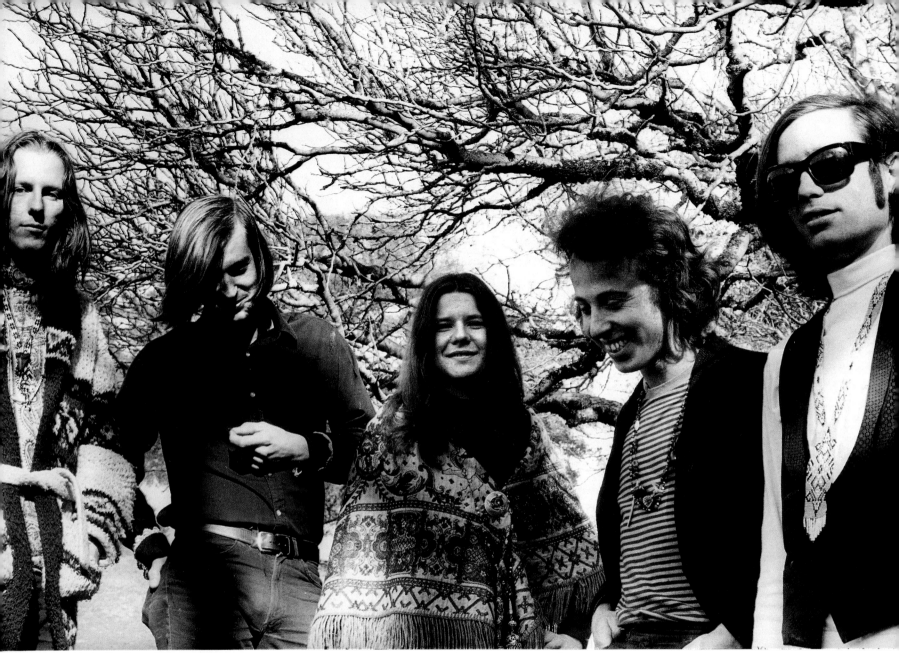

Janis Joplin and Big Brother
and The Holding Company,
Woodacre, 1967

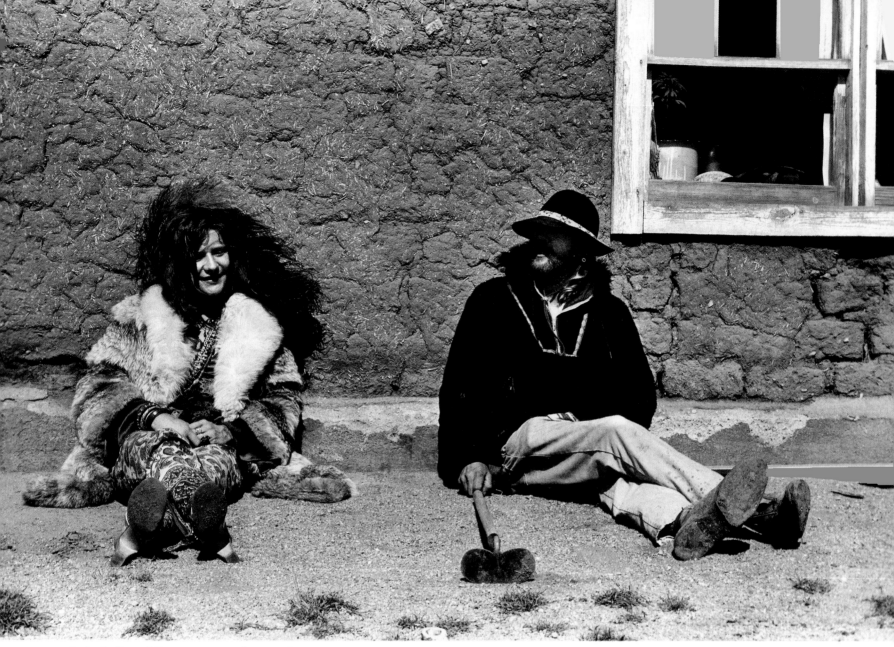

Janis Joplin and Tommy Masters (horse trainer)
outside our house in Truchas.

n 1970, Janis came to Taos with her manager, Albert
Grossman, to do a cigar commercial on the Rio Grande
gorge bridge. Tom and I went to greet them at the La
Fonda hotel. Janis whispered in my ear as she hugged
me, "You can help me, help me!" I thought, at last I can
do something to help Janis because she always seems so
troubled. "I'm tired of these city men. I want me a
mountain man." This photo was taken at 1 P.M. the day
after she found her mountain man, who lived in a small
adobe house at the foot of the Sangre de Cristo moun-
tains in the Penetente village of Truchas.

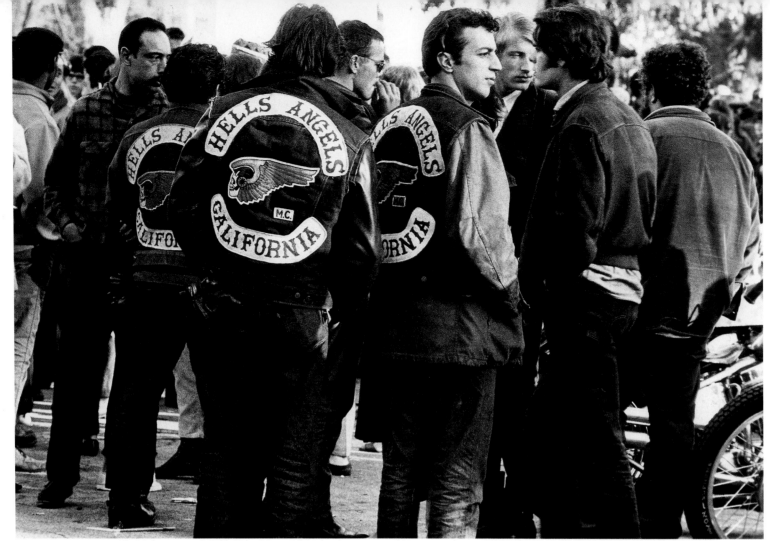

The Hells Angels, weekend gathering, the
Panhandle in Golden Gate Park,
San Francisco, 1967

*There was such a sense of community. . . . It was as if all
the Martians and the Venusians found each other. There
was a tremendous feeling of warmth and love and laughs
and body contact, sensual, not harsh.*

Paul Krassner

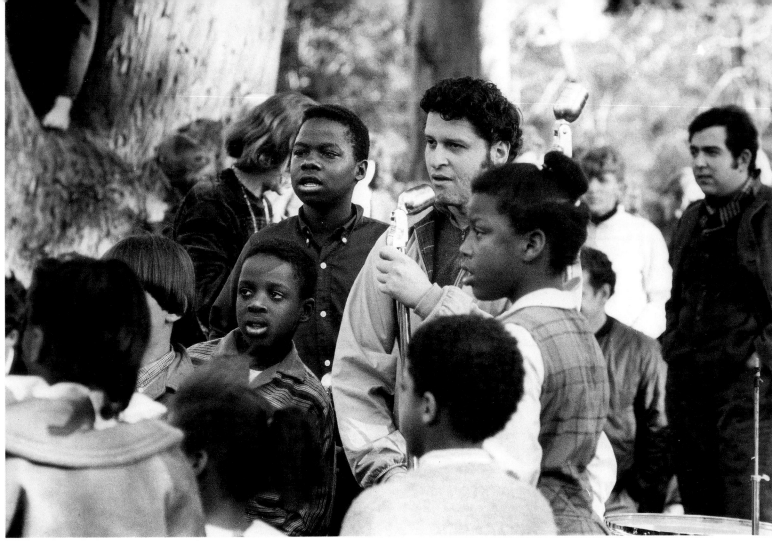

Paul Krassner and Harvey Kornspan,
the Panhandle, 1967

Ron and Jay Thelin had just opened The Psychedelic Shop in the Haight-Ashbury, and Bill Graham and Chet Helms and Company were putting on shows at the Fillmore Auditorium and the Avalon Ballroom in San Francisco. Lots of music was being played in the Panhandle of Golden Gate Park. The Diggers were feeding the masses every day in the park. A. C. Bhaktivedanta Swami Prabhupada had a little chapel where he had a small group of followers chanting "Hare Krishna, Hare Krishna, Krishna Krishna Hare Hare, Hare Rama, Hare Rama, Rama, Rama, Hare Hare." He was marrying couples weekly. Barefoot, beaded hippies were everywhere. Pot and acid were used by almost everyone. People were living communally, sleeping on floors as if they were in dormitories. We were all flower children, all one. Runaways could be found in Haight-Ashbury if Mom and Dad cared to look. That was where it was happening. A newspaper appeared, the *Oracle,* with Gabe Katz as the creative director and sometimes editor. Several times I took him photos to use.

My brother and I were from a merchant family. My father was manager of a Woolworth store. We grew up running in the aisles, taking inventory, being stock boys. So when the psychedelic thing happened, opening a psychedelic shop was a natural way for us to express ourselves. After we opened up we realized our shop was right across the street from the first Woolworth store our father had ever managed.

We opened The Psychedelic Shop on January 1, 1966, and closed it on October 6, 1967. That was the Death of Hippy Day. We gave away everything. It seemed to us that people were adopting the lifestyle as a matter of style, without any thought going into why they were doing it. Without real purpose. We put up a funeral notice: Hippy, beloved son of media. Then we carried a coffin filled with beads, flowers, and hippy artifacts down Haight Street. When we got to the Panhandle, we turned it into a funeral pyre. There was food, and a band played. The next day Arthur Lisch and I bought a white panel truck and went to Washington, D.C., for the exorcism of the Pentagon.

Ron Thelin

Haight-Ashbury, 1967

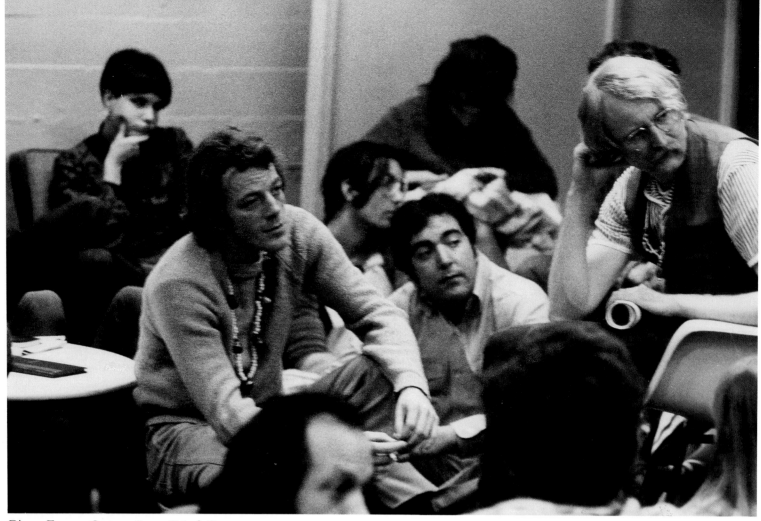

Digger Emmett Grogan, Susan Grinel, Harvey Kornspan, Richard Brautigan, Gene Grimm (very front) at an Artist Liberation Front meeting.

Emmett Grogan was a real visionary guy. At his best he was absolutely charismatic. He could get anybody to do almost anything. An outlaw and an anarchist, Grogan was the founder of the Diggers, a loosely formed anarchic organization that was into consiousness-raising. It was a counterculture welfare system that fed and clothed the stoned kids with all the dreams.

The free-food program was a way to show the establishment that there were a lot of people who needed to be fed. Many people had come to San Francisco thinking that free love was a panacea and that life would go on, and never ever thinking about the fact that they didn't have any money to buy food.

The Diggers would set up a twelve-foot yellow frame against a tree. If you were on one side looking in, it was your frame of reference, and if you were on the inside looking out, that was your reference. It was called the free frame of reference. Wherever it got set up, the food thing was going to happen.

Harvey Kornspan

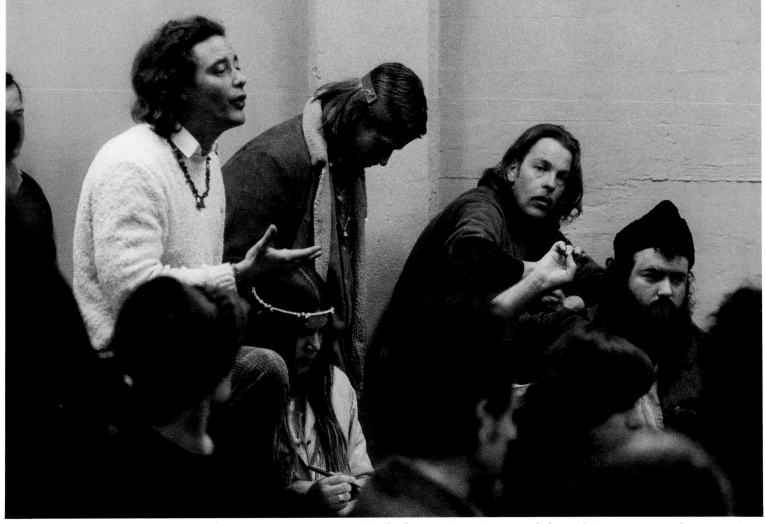

Michael Bowen, Tom Law, Ron Thelin, and Lee
Myershoff at the Artist Liberation Front meeting.

There was a meeting of the Artist Liberation Front, where
a bunch of disparate people came together to organize
a clearinghouse and to discuss what resources were
really available and what kinds of events could be coor-
dinated for the artist community. People within that
group started the Diggers.

Allen Ginsberg

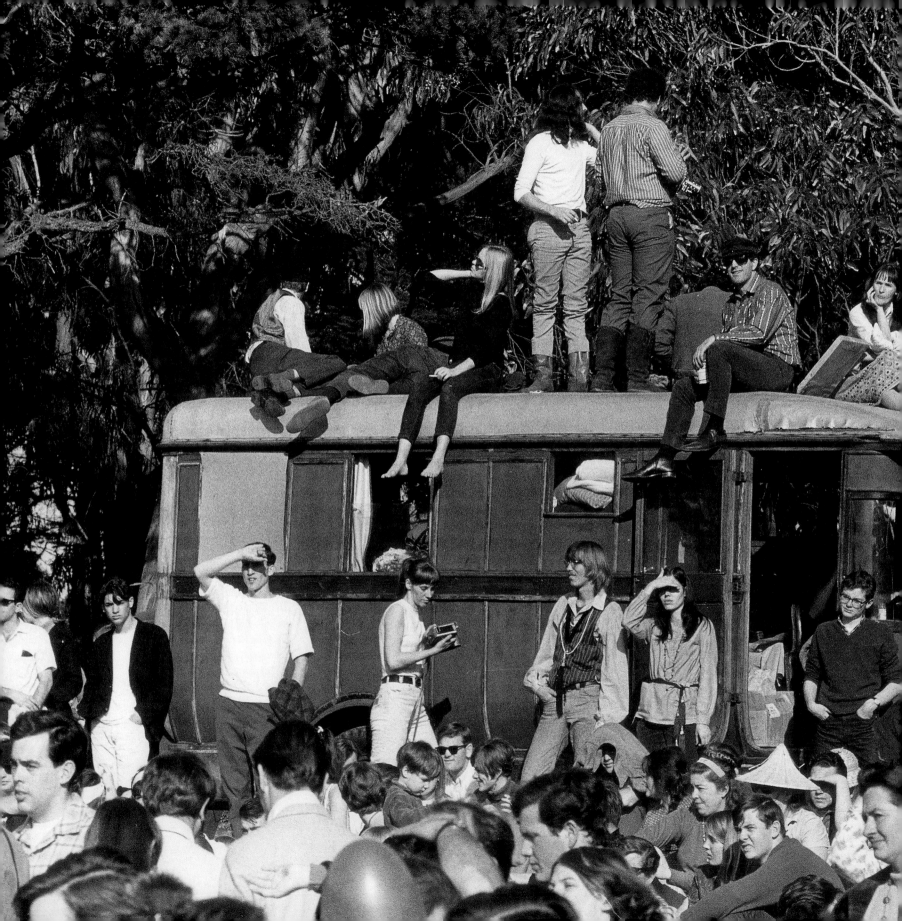

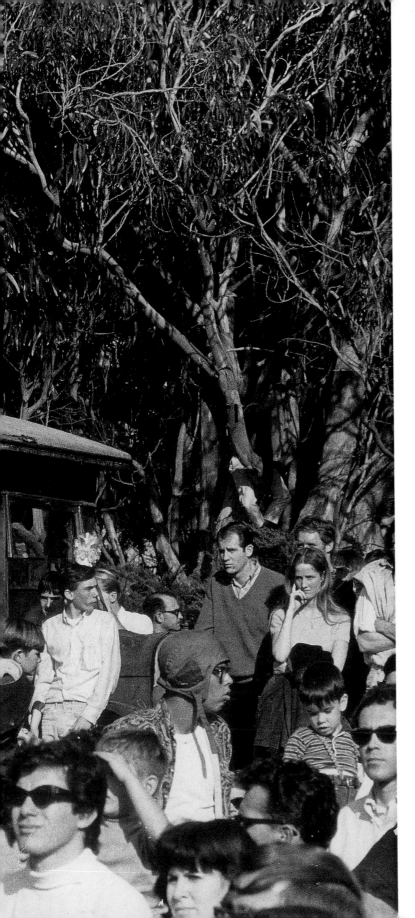

It was the Gathering of the Tribes and certainly a field day for acid. Someone remembers seeing a plastic bag full of ten thousand microdots that were to be handed out for free. The feeling was of brotherhood and love. I was having trouble focusing my camera. Four orange flares were set off to announce the heavenly descent of a man in a parachute who everyone thought was Owsley, the inventor of blue acid. Tom and I were spiritually married by Reno, a friend, as the sun set over the Pacific Ocean.

Something different was happening; ten thousand people turned up. It was out of sight, out of this world, that this many people were starting to feel different about their place on earth and their responsibility to the earth and what the meaning of life was.

 Ron Thelin

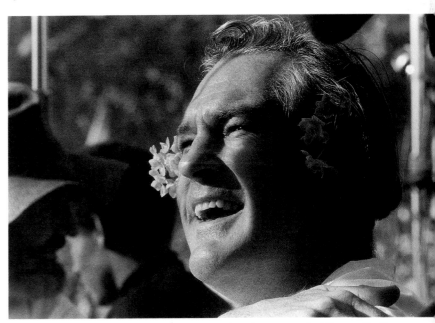

Timothy Leary, the Human Be-In, Golden Gate Park, January 14, 1967

Turn on, tune in, drop out.

 Timothy Leary

Behind the stage of the Human Be-In

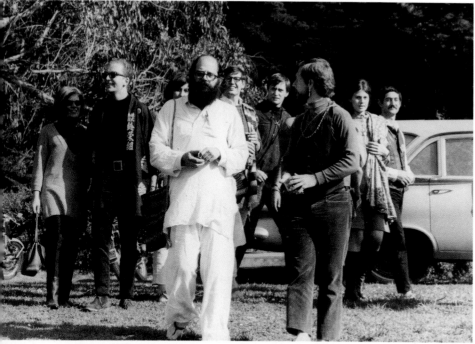

Allen Ginsberg and Gary Snyder (in front), the Human Be-In

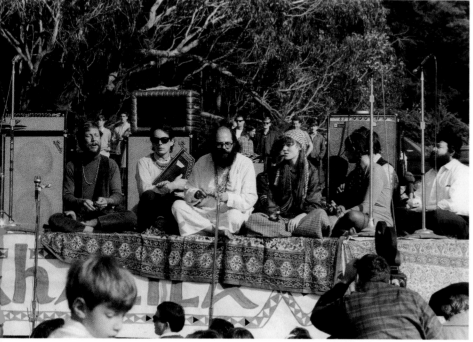

Gary Snyder, Michael McClure, Allen Ginsberg, Maretta Greer,
and Lenore Kandel, the Human Be-In, January 14, 1967

Gary Snyder and I tried circumambulating Golden Gate Park meadow chanting "Darani for Removing Disasters" (See D. T. Suzuki's Manual of Zen Buddhism*) and a Tibetan purification mantra to all the Dakinis (sky goddesses): Om, Om, Om, Sa Ra Wa Buddha Dakini yeh Benzo wa Ni Yeh, Benzo Bero Tsa Ni Yeh, Hum Hum Hum Phat Phat Phat Svaha (repeated to us by Miss Maretta Greer, back from four years on streets of Nepal, Benares, Kathmandu, and Valley of Ladakh). So that's us striding back from circumambulation ringing hopeful bells and heading toward nervous system platform, January 14, 1967. We chanted "Om Sri Maitreya" to the setting sun of ten thousand people when day was done. Dharma warrior Suzuki-roshi (founder of San Francisco Soto Zen Center in 1958) had spent the afternoon sitting on the stage boards beside us, flower in his hand, in Zazen rest amid the celebrations and miseries of Human Be-In excitement. In midday The Grateful Dead roared onstage after Gary, Michael McClure, Larry Ferlinghetti, Lenore Kandel, and I read poetry. There's myself wild naive India white cotton and beads suddenly up on my feet inspired (for the first time I ever heard rock 'n' roll right out loud onstage), dancing and yelling in rhythm to the band. (It took me fifteen years to learn to do the same thing with my own words and music; this was the first time I shook my ass on the electric stage.) The Beard behind me was passing out thick strong-smoked peace pipe of powerful hash ganja grass. I got elated and so started that dance rising suddenly on one foot in joy.*

Allen Ginsberg

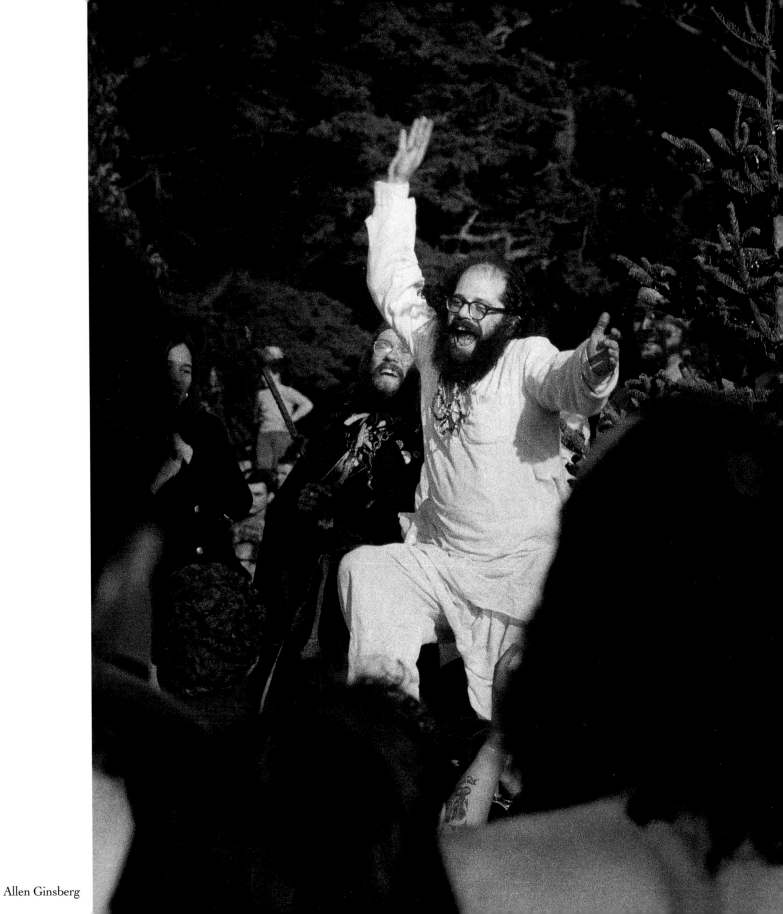

Allen Ginsberg

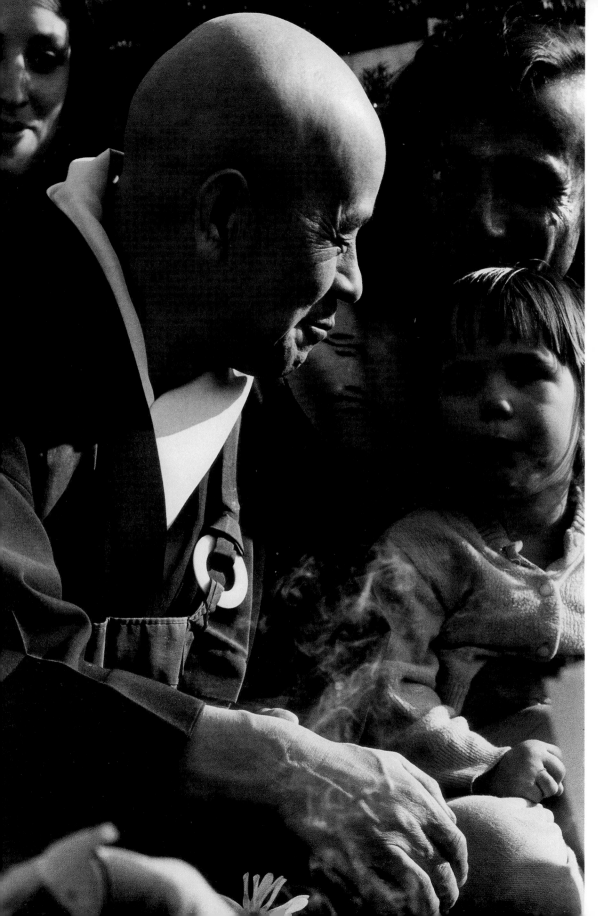

Suzuki-roshi was about the only major Buddhist teacher who came to the West who decided to stay in one place and commit himself to the students who practiced with him. He was also committed to teaching meditation and being there for people in their meditation practice. He treated practice as a lifelong activity, not something you jump into and get enlightenment with some technique. He had studied Western philosophy, and he'd committed himself when he was very young to coming to the West because he thought that Buddhism would prosper—it was too stale in the Orient.

He was like a rose with a lot of thorns right under the petals.

Richard Baker-roshi

Suzuki-roshi

It was the media coverage of the Human Be-In that destroyed the spirit of Haight-Ashbury. The publicity precipitated a massive statewide migration of America's runaways, outcasts, and outlaws, and with them the heavy drugs, speed especially. That was the beginning of the end of the Haight.

Emmett Grogan, of the Diggers, got word that *Time, Newsweek,* and the TV networks wanted to interview him, so he told members of the Diggers to tell anybody who asked where to find him that they were Grogan. A girl appeared on TV being interviewed as Grogan.

Emmett Grogan

Lawrence Ferlinghetti, the Human Be-In

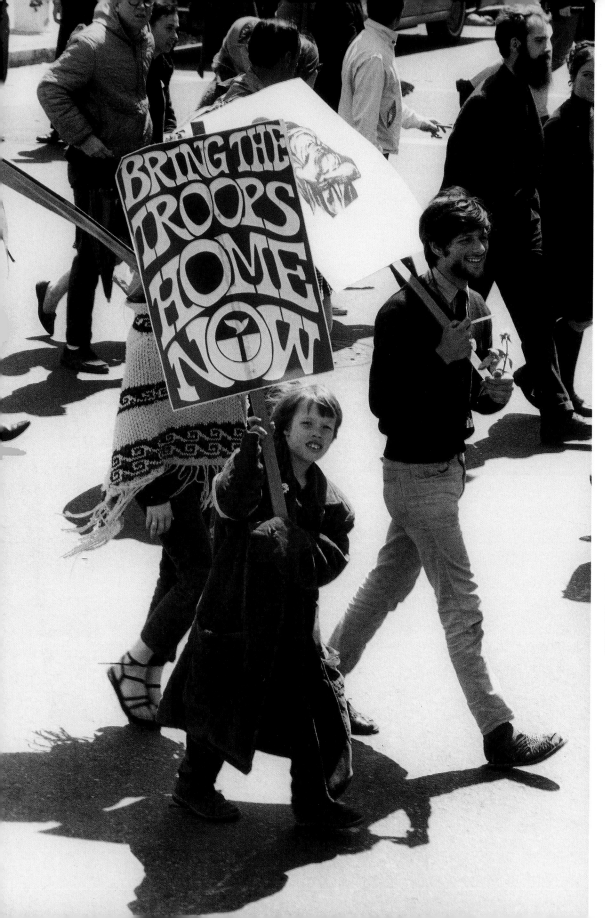

F lower children could be seen marching down Market Street with thousands of other concerned citizens, marching against the war in Vietnam, in counterpoint to the boys who were sent to fight in the jungles half a world away. The juxtaposition was quite astounding.

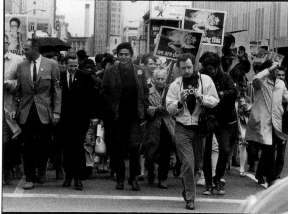

Anti-Vietnam march, San Francisco, 1967

General Hershey Bar, antiwar activist

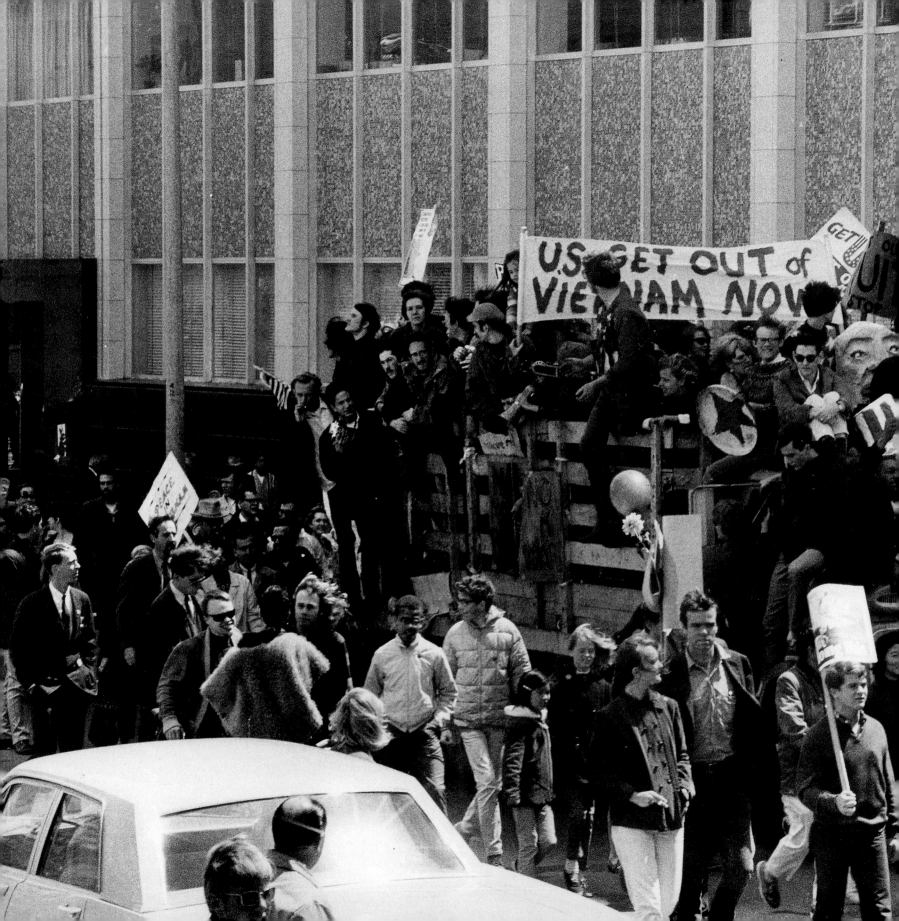

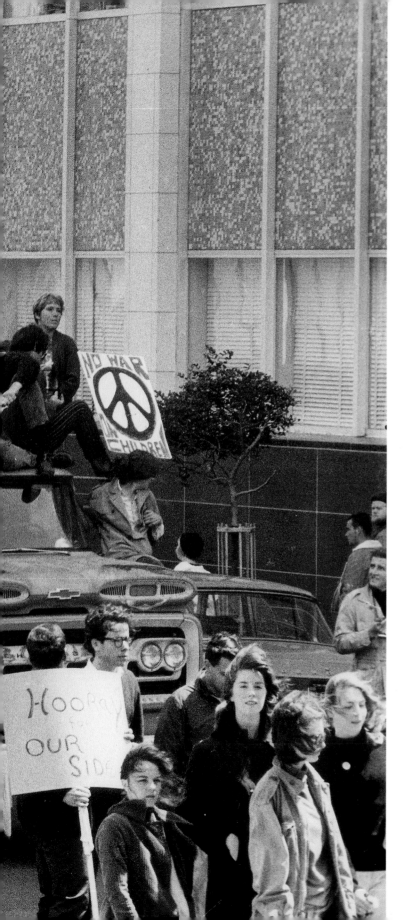

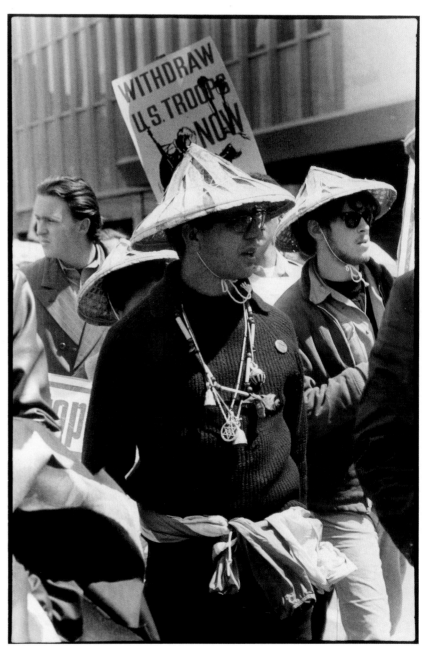

Left: Anti-Vietnam peace march, Market Street, San Francisco, 1967 *Above:* Ted (Haia) Berk, poet, philosopher, marching in anti-Vietnam march, San Francisco, 1967

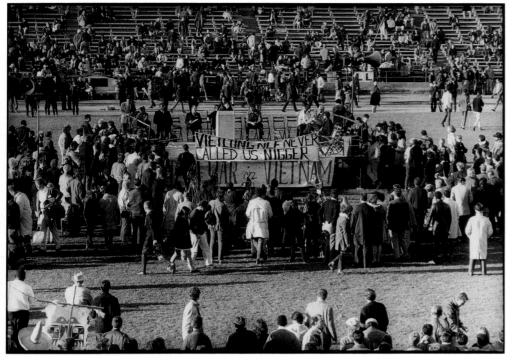

Anti-Vietnam War rally, Coretta Scott King, speaker,
Kezar stadium, San Francisco, 1968

Coretta Scott King at rally

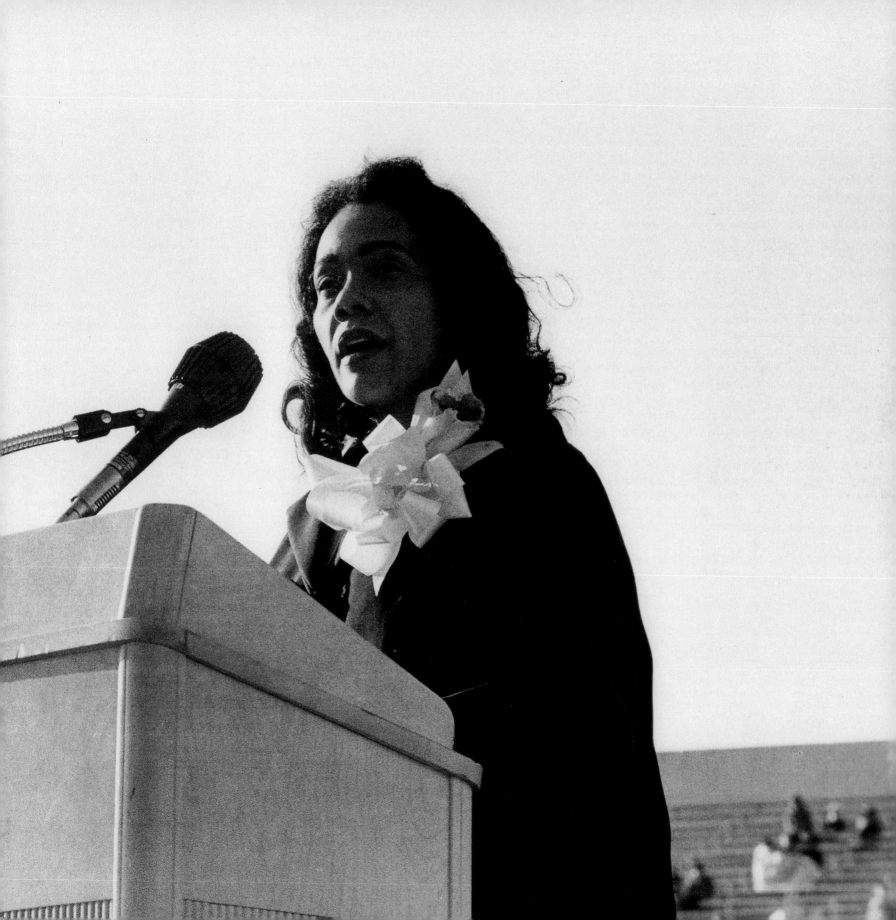

The Committee was a topical, improvisational review started in San Francisco by some disgruntled Second City members. We took our inspiration from everything that was happening all around us. We did our homework. We read newspapers every day: the Chronicle, *the* Examiner, *the* New York Times. *We read the London* Economist *and* I. F. Stone's Weekly. *We were steeped in the news because that was what we were using for the raw material of our comedy.*

The sixties were rich with contrast and excitement. A lot of ground was being broken and we were there to make fun of it. We made fun of Nixon, Johnson, the hippies, dope smokers, people who took acid and people who didn't. Everybody was a target. Everything was potentially funny and we were uncompromising. We took a lot of chances. There was Peter Bonerz, Howard Hesseman, Chris Ross, Leigh French, Alan Myerson, Nancy Fish, Morgan Upton, and many others. Robin Williams was in the Committee Workshop. He was too young to be in the show.

If you had to be anywhere in the sixties, where better than San Francisco? It was a time when, if somebody had long hair and smoked dope, you could trust him with your life. All of a sudden I had an entire second adolescence. I got to do it in the fifties when I was sixteen, seventeen, and again in the sixties when I was twenty-six, twenty-seven. I did all the things I did when I was young once more. I rediscovered art and politics. I questioned basic assumptions and attitudes. And I was able to do it all from the vantage of having been an establishment guy for ten years. I had been in the army. I had traveled around. I had had a life. Then I was a kid again.

Carl Gottlieb

Kathryn Ish, John Brent, Garry Goodrow, and Larry Hankin, The Fool's Play, San Francisco, 1967

Kathryn Ish, John Brent and Garry Goodrow,
The Committee, The Troubadour, Los Angeles, 1966

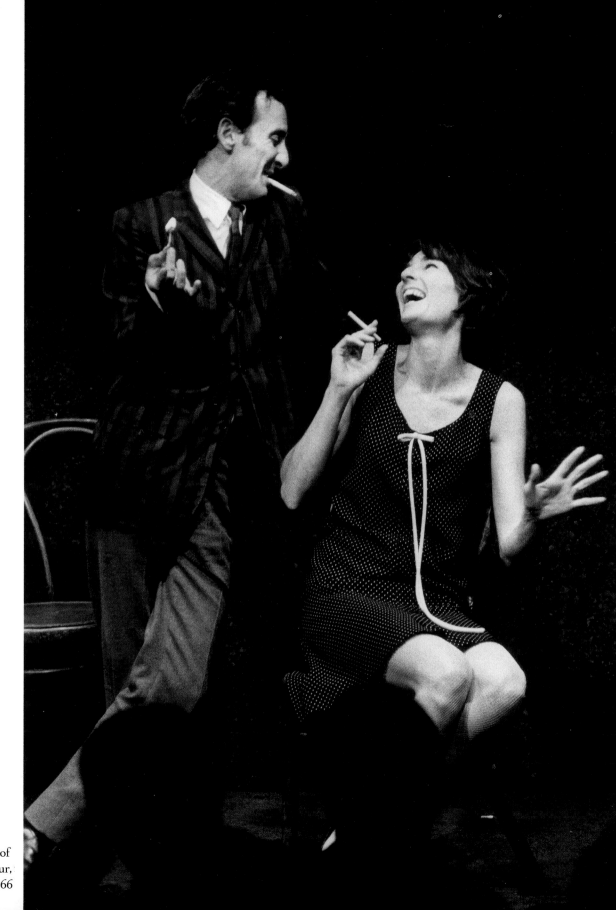

Garry Goodrow and Jessica Myerson of
The Committee, The Troubadour,
Los Angeles, 1966

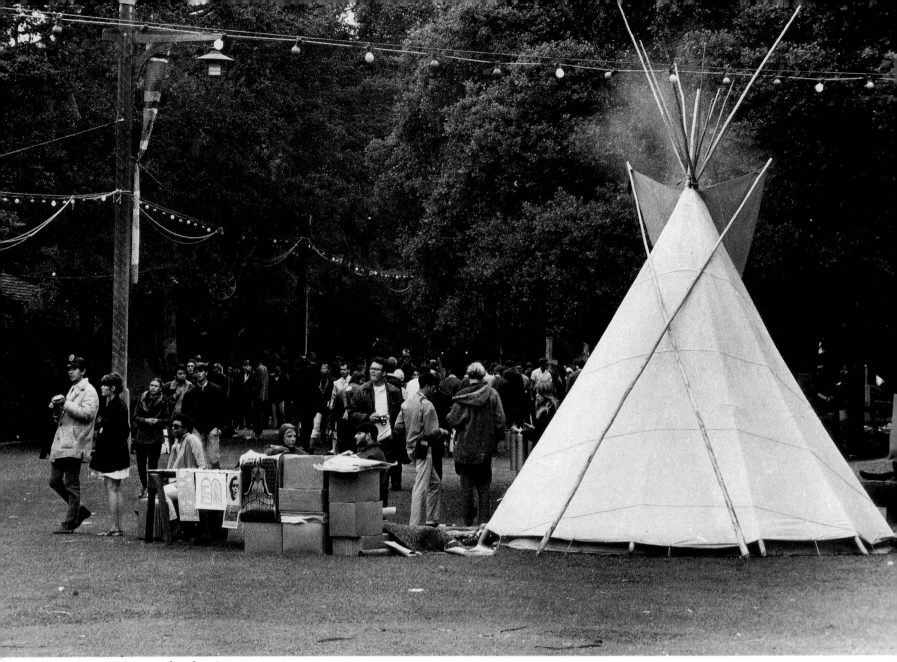

Our tepee was used as the trip tent,
Monterey International Pop Festival, June 1967

We took our tepee to the Monterey International Pop Festival, where it was used to calm and center those people who were freaked out on acid. One evening at dusk I was sitting in the tepee next to the fire with five other people. We were all staring into the fire, and it was very quiet. The flap of the door opened, and a breeze went counterclockwise around the room, very low to the ground, and then left again by the door. Everyone felt it and knew that we had been visited by a very special spirit.

Monterey was beautiful. The police were wearing flowers in their hair. The music left us ecstatic. All of the top groups were there. Janis Joplin made a name for herself sharing the stage with such great musicians as The Who, The Paul Butterfield Blues Band, Otis Redding, The Mamas and Papas, Ravi Shankar, Simon and Garfunkel, The Jimi Hendrix Experience, and many more.

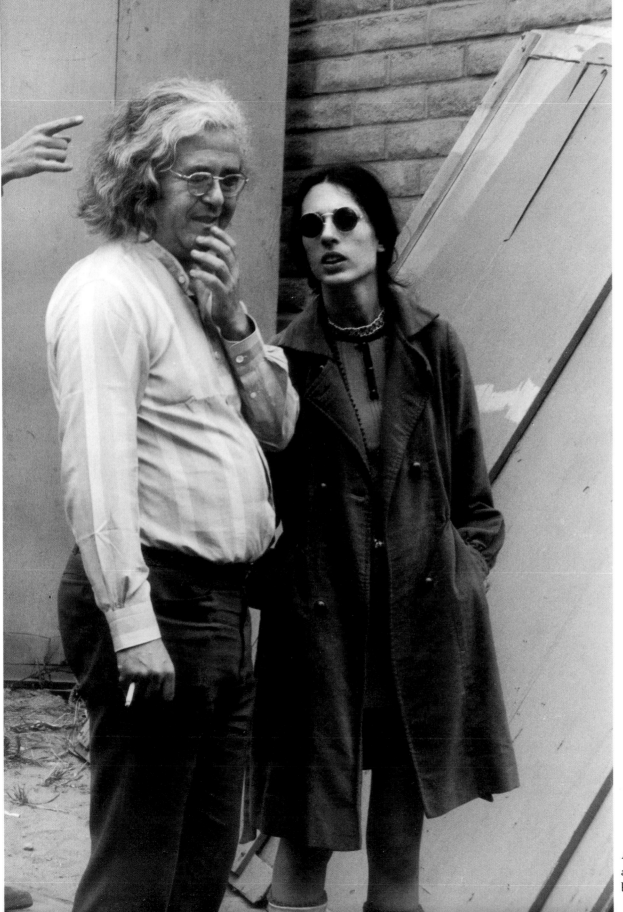

Albert (Dylan's manager)
and Sally Grossman
backstage at Monterey Pop

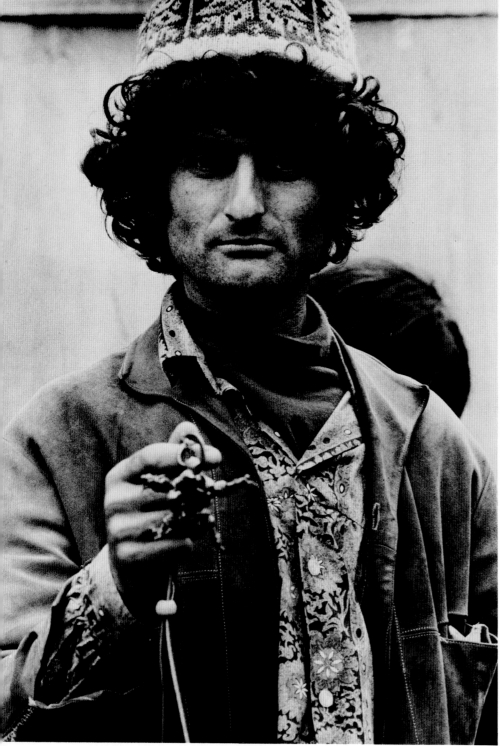

Victor Maymudes, Dylan's road manager,
with burnt baby mandala, Monterey Pop

The Monterey International Pop Festival was a gathering of like minds from the world of art. Though the music was predominant, there were all kinds of artists there. It took place at a time of great social injustices. The festival itself was a monument to the protest against these injustices—the Vietnam War, for instance, and the social struggle at home.

Woodstock was another example of this very thing. But whereas Woodstock was the teenager, the Monterey Pop Festival was the birth of getting together like that.

Actually, if we remember our history correctly, the love-ins and be-ins preceded the Monterey Pop Festival, which came out of the marches, which came out of the protests, the anguish of the population itself. All those people who couldn't handle it found themselves through song.

Throughout the festival, I carried a mandala of burnt plastic babies. Mandalas are usually symbols of life. But what could remind you more of how fucked up it was, how bad it really was, than a mandala of burnt babies. For me, it was the issue, the protest. We were dropping napalm at that very moment on Vietnam. We were burning babies, we—the United States—were burning babies.

Around the country the protest was in full swing, and we were demonstrating at the Dow Chemical Company. But Monterey Pop wasn't like the marches through the cities, which are more educational to the people who stand on the sidelines. It was a very political event in which nobody got on a soapbox to say the obvious. Instead it was a celebration. It was itself a major statement.

Victor Maymudes

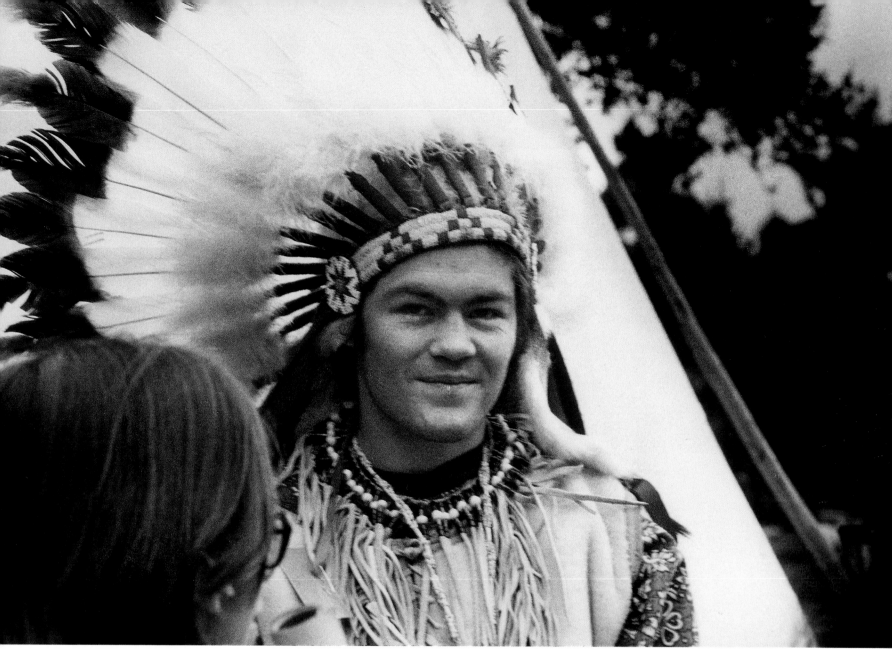

Mickey Dolenz of The Monkees at Monterey Pop

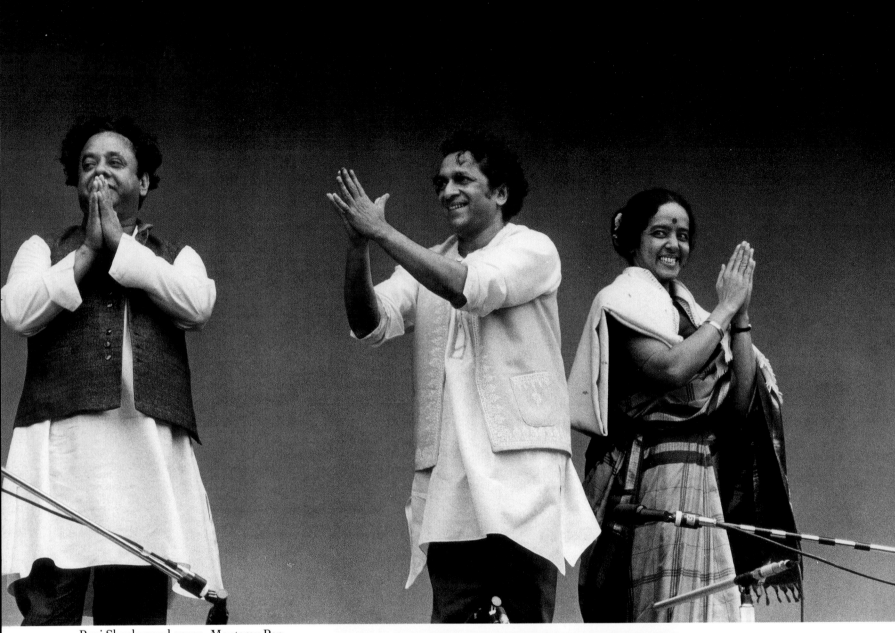

Ravi Shankar and group, Monterey Pop

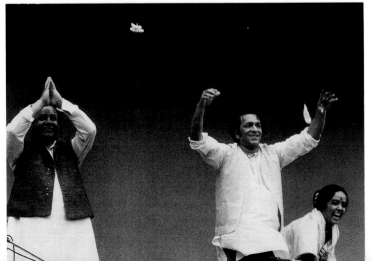

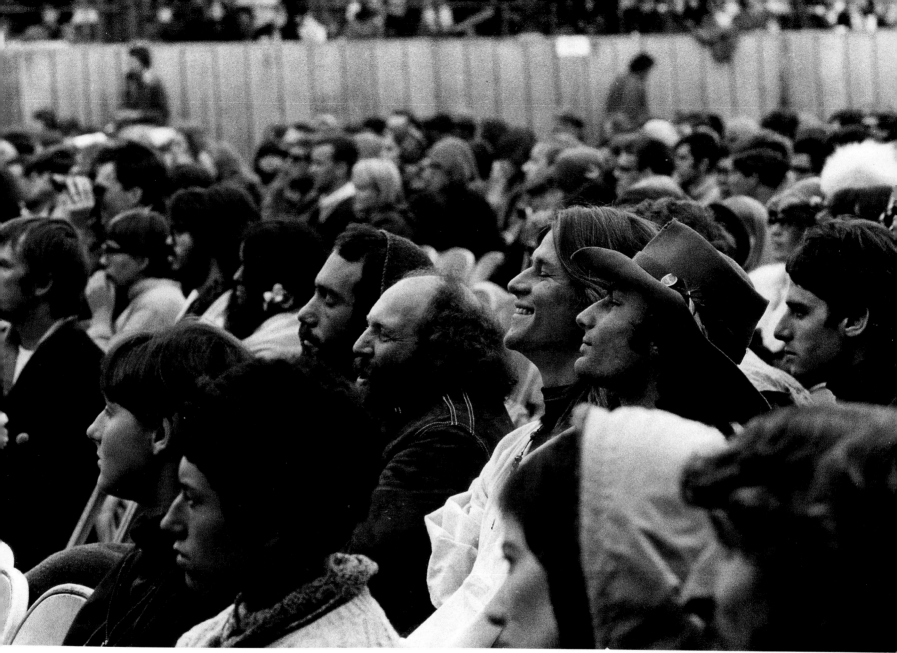

In total ecstasy with Ravi Shankar's music

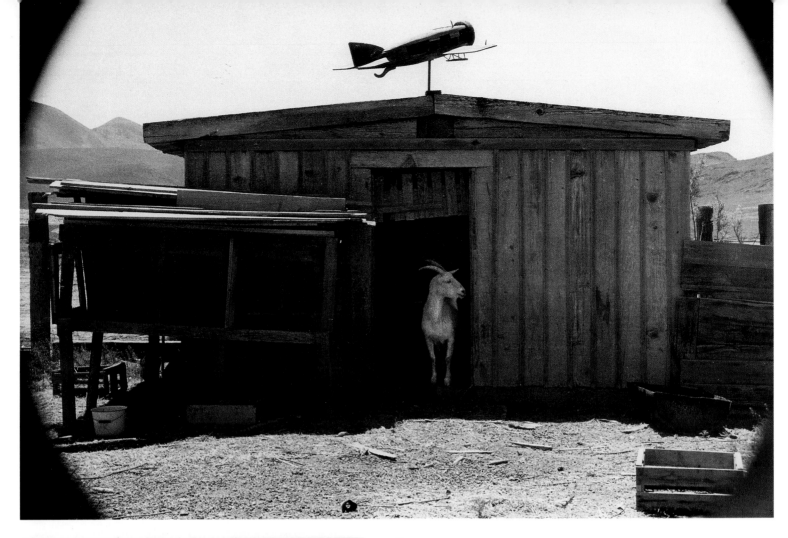

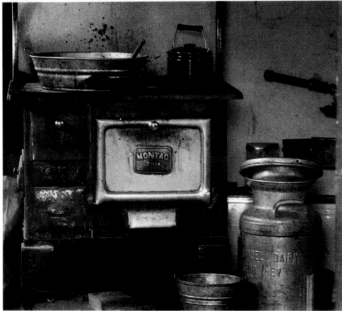

Above: the Melvilles' barnyard.
Below: the Melvilles' kitchen.

n May 1967 Tom and I lived in our tepee in Nicasio, California, getting it ready for our travels. It was wonderful living in a tepee. We had rugs and a foam mattress, and we made a place for a fire in the middle. It was always so quiet and peaceful and simple inside—a perfect environment for meditating, thinking, and playing music. It was easy to keep clean, and we didn't need much furniture, and it moved when you did to another location, with only a few hours' work.

We decided to take a trip to Pyramid Lake in Nevada, and met Robin and David Melville while we were there. We camped next to a stream where watercress and alfalfa were growing nearby. The Melvilles had two children, one born in Huautla, Oaxaca. The other child was born in Santa Fe, New Mexico, at the Catholic Maternity Institute.

I loved Robin's house and the simple way she lived with goats and chickens and a wood stove. It looked hard, but she seemed happy and very close to her family. I was set on having our first child naturally, which was not fashionable at that time, so I told Tom I wanted to go to Santa Fe for the birth.

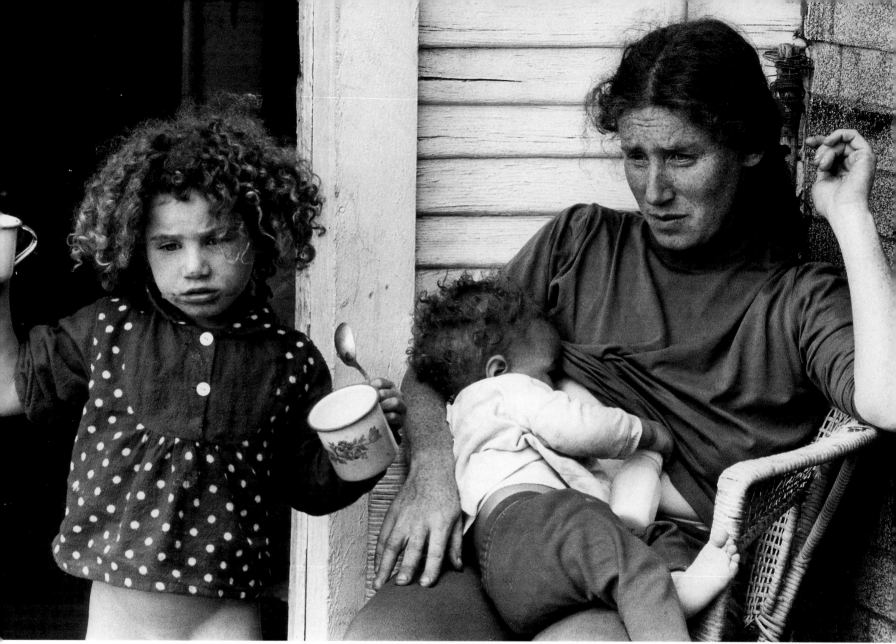

Robin Melville and children, Pyramid Lake,
Nevada, May 1967

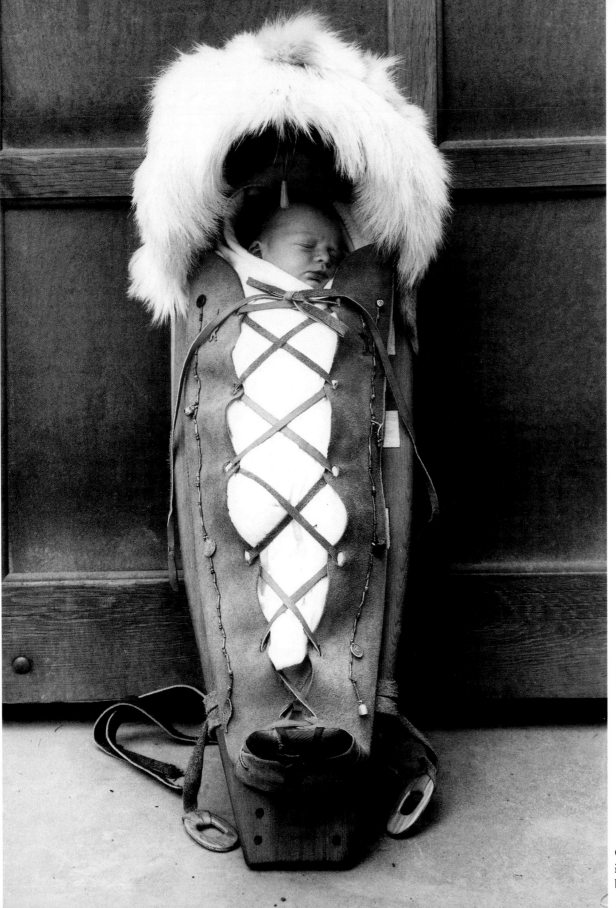

Our first born, Dhana Pilár,
in a cradle board made
by Steve Hinton and me

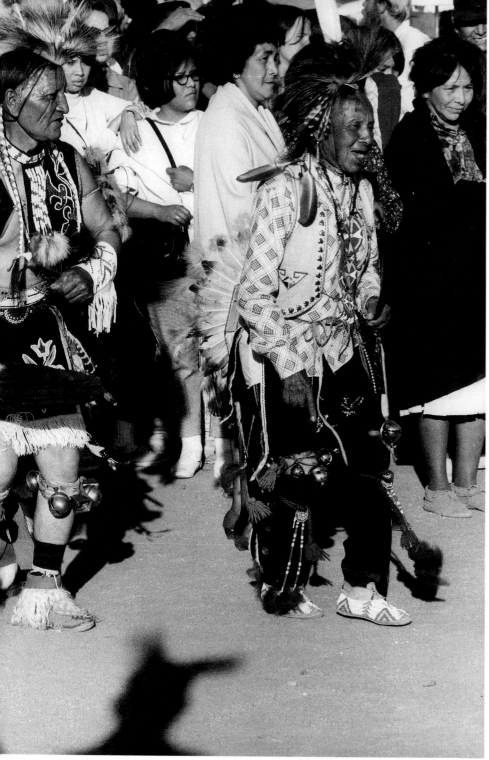

Ben Marcus and Little Joe Gomez of the Peyote
Church of the Taos pueblo

New Mexico really was the Land of Enchantment. We could feel the vibrations of the presence of thousands of years of Indian nations living on the land. Some geographical areas reminded me of the moon. There weren't many people living in the northern part of the state, around Santa Fe and Taos. We felt like frontier people.

One of the first communes to appear in New Mexico was New Buffalo. Situated in the small community of Arroyo Hondo, north of Taos, it was a social, religious, scientific, and work-oriented agricultural commune. The members wanted to be self-sufficient, primitive, and closer to reality in terms of the simple things of life. "People were taking drugs and seeing God. We wanted to get away from the urban, white-middle-class, capitalistic society we were brought up in," said New Buffalo's founder Rick Klein, who used his inheritance to found the commune. We went to visit them, set up our tepee with theirs, and felt right at home.

We learned how to chop wood, peel vigas, and make adobe bricks. Women wanted to deliver their own babies instead of going to the self-made gods who delivered babies in hospitals. Breast-feeding was making a comeback.

The Native Americans of the Taos pueblo helped the New Buffaloers by being friends and teachers, and the young people of the pueblo in turn gained self-respect when they saw other men with long hair. Little Joe was a traditional elder of the Taos pueblo and many times included our people in his ceremonies. Psychedelics are nothing new to the Natives. They use them for healing and bringing the family closer together. Their spiritual life is their way of life, not something they do on Sundays. The way of the Native Americans encouraged us to go on in our search for harmony with what Mother Nature had given us. Life seemed like a fantasy, but living and working the land was real. We were allowing ourselves to experiment, to dare to try something new.

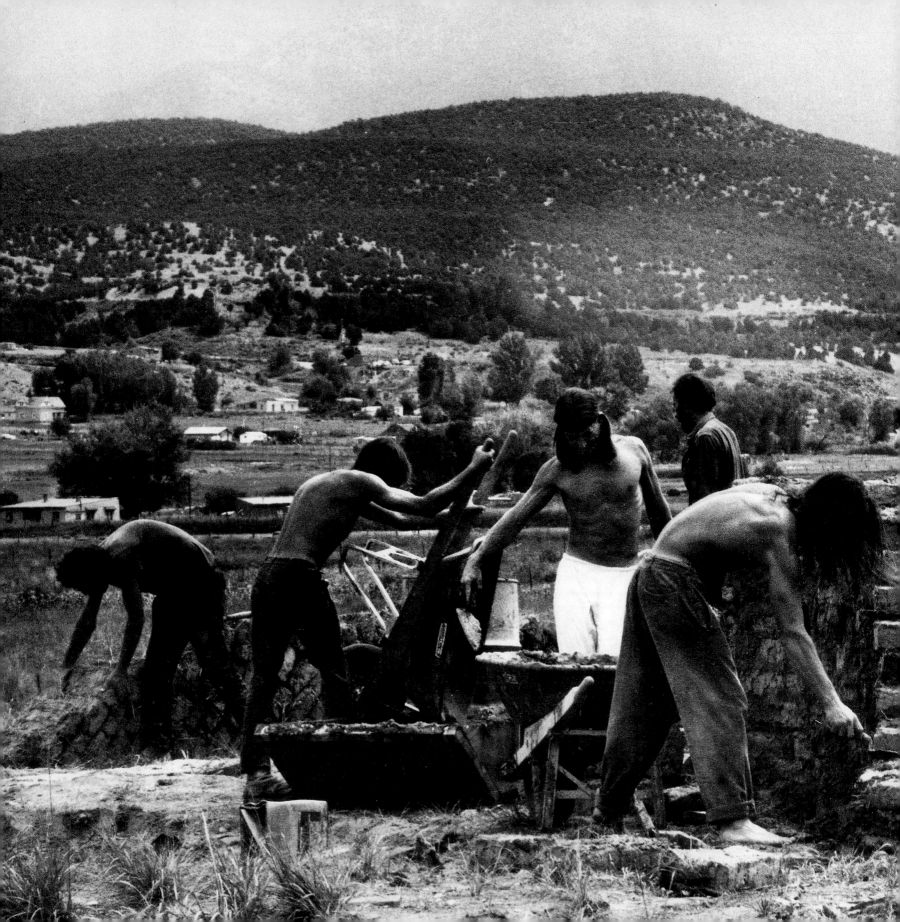

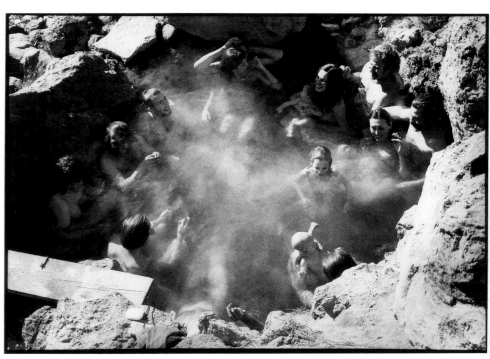

Spence Hot Springs, Jemez Mountains,
New Mexico, 1967

Building the communal house at New Buffalo Commune,
Arroyo Hondo, New Mexico, August 1967

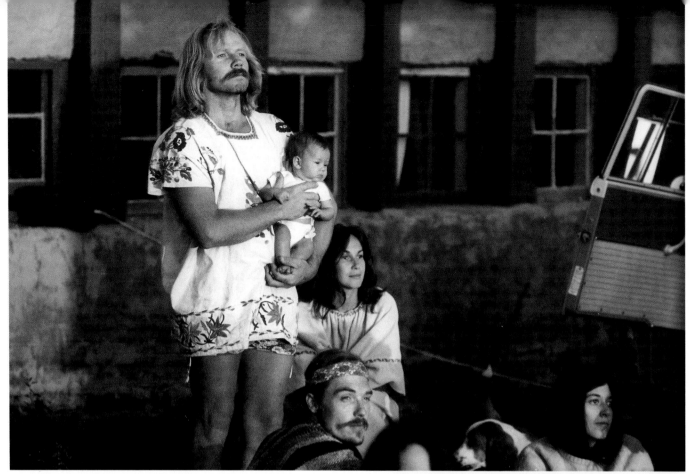

Barry, Patti, and their baby Ever McGuire, Bernard,
and Cindy Gallard, watching the sunset the night I
went into labor with my first child, Pilár, Seton Village,
New Mexico, 1967

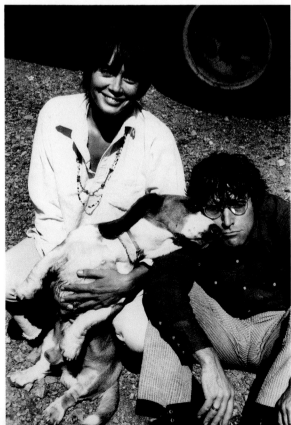

Jerry Elam and Ramblin' Jack Elliott at
Spence Hot Springs in the Jemez Mountains,
New Mexico, 1967

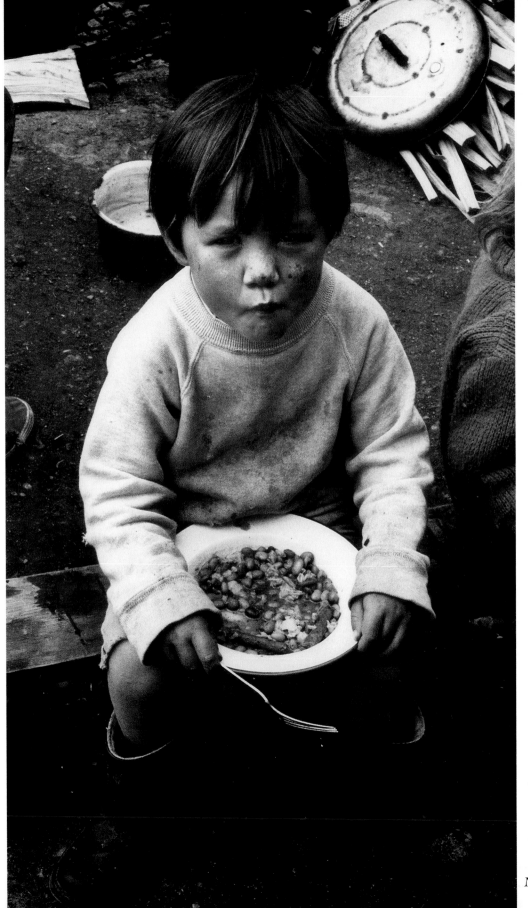

Miles Hinton, New Buffalo, 1967

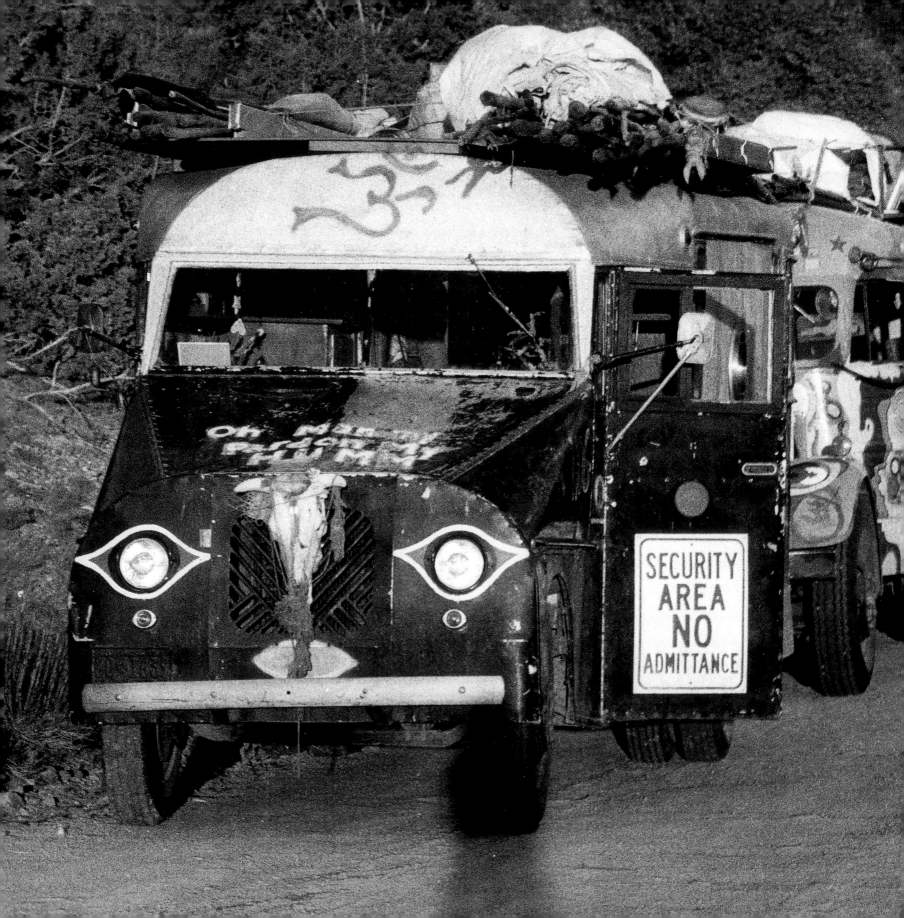

Caravan gearing up for Love-In at Los Alamos atomic proving grounds at Black Horse Mesa, New Mexico, 1968

Wavy and I were living in a house in Hollywood. Tiny Tim and Severn Darden were there too. And Neal Cassady and Ann Murphy. Kesey wasn't there. He was hiding out in Mexico. Then Babbs and all the Pranksters moved in with us when they were doing the Kool-Aid Acid Tests. It was a zoo, so Wavy and I moved out to a little cabin in the woods in the Sunland/Tujunga area. Then Babbs pulled a prank on the Merry Pranksters. He told everybody they were going to be on the cover of Life *magazine. All they had to do was pile into their bus and ride out to a neighbor's house where the photographer was waiting. When they got out there, Babbs and a couple of the other Pranksters snuck out back and took off for Mexico in the bus. So we had most of the Pranksters living with us again.*

About that time a friend of ours who lived up the hill from us as a caretaker on a hog farm had a stroke and had to move out. He asked us if we'd like to live up there rent free and slop his hogs. We spread out over the farm's entire sixty acres, living in huts, trucks, tepees, and the main house. This was all to the horror of the wealthy residents of the valley below us. They became convinced we were communists and were planning the overthrow of California. Soon there were vigilantes guarding the road off the hill, and we had to use a little access road down the back of the hill to keep from getting shot.

Eventually, as the neighbors got to know us, their hysteria died down. Then they started showing up at all hours to see what we were about. That's when we started having celebrations on the weekends. We'd play croquet in formal dress or throw a county fair, figuring if we got all the people there at one time, we'd have the rest of the week to ourselves.

We lived innovatively back then. I was the money commissioner, and everyone who made money gave it to me. I'd pool it for food. One hundred pounds of brown rice was eleven dollars.

About that time three of the guys in the family who worked in a gas station surprised us with our first bus. It was time to go on the road. I became ruthless, collecting everybody's checks. We needed to stock up on food for the road, and we needed gas money. Just when we had gotten it all together, a friend of the family's was busted. Half of our road money went to bail him out. We ended up with only half the supplies we thought we were going to need, but we never knew where too many of our meals were going to come from anyway, so it all seemed perfectly cosmic to start out on the road that way.

Bonnie Jean (Jahanara) Romney

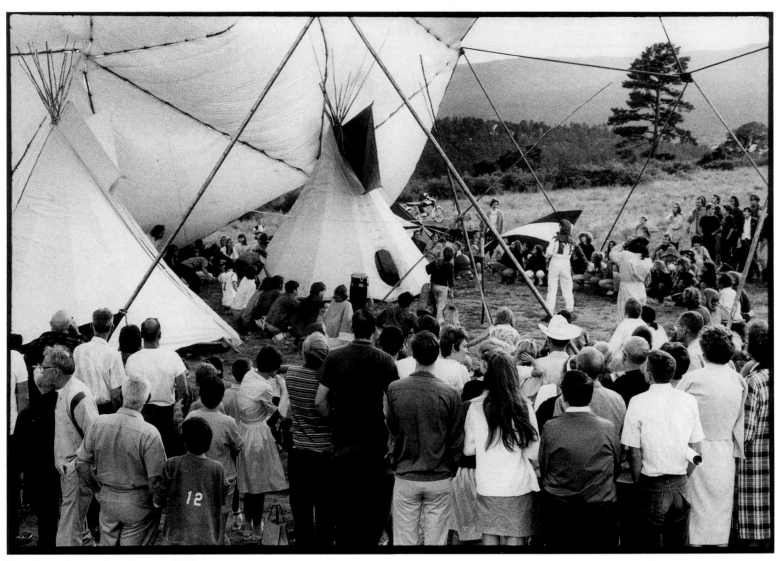

Hog Farm show at Los Alamos, 1968

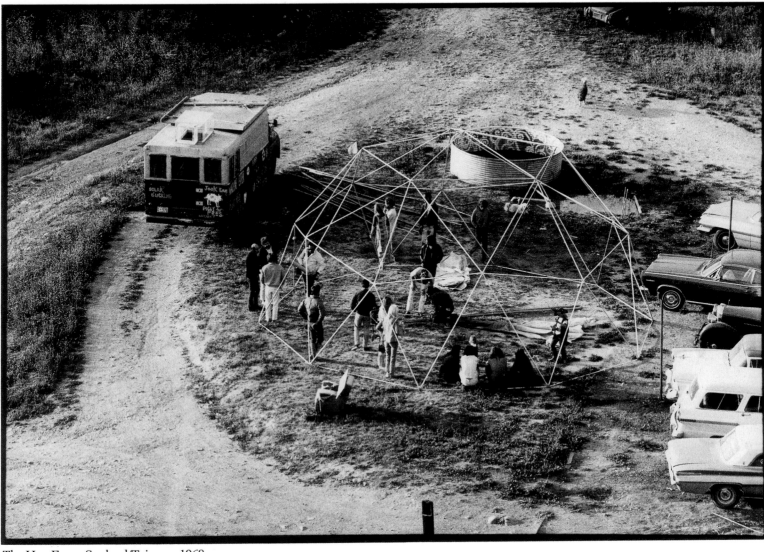

The Hog Farm, Sunland/Tujunga, 1968

The Hog Farm camp, El Valle, New Mexico,
1968

The Hog Farm. They were the only people who knew what to do. The planet was in full crisis. Remember 1968 out there in media land? If you weren't getting your ass kicked off in Khesanh, you were probably getting your head whipped in Chicago or getting gassed in New York or drafted in Florida. My generation was a year or two away from Kent State. I was with the Hog Farm because I had been living in Chicago, working at Second City, and I knew that was what was coming, and I didn't want to be around, so I went and hid with the pig and stayed cool in the mountains. Not with any intent; it just seemed to happen that way.

Terence Ford

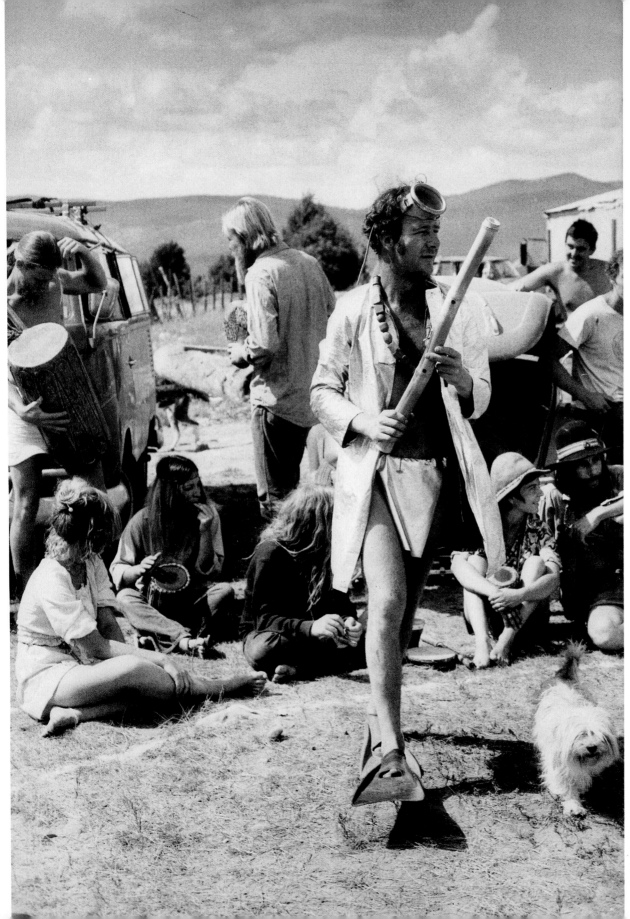

Wavy Gravy at the Hog Farm
in Llano, New Mexico, 1969,
with Tzingee, our dog

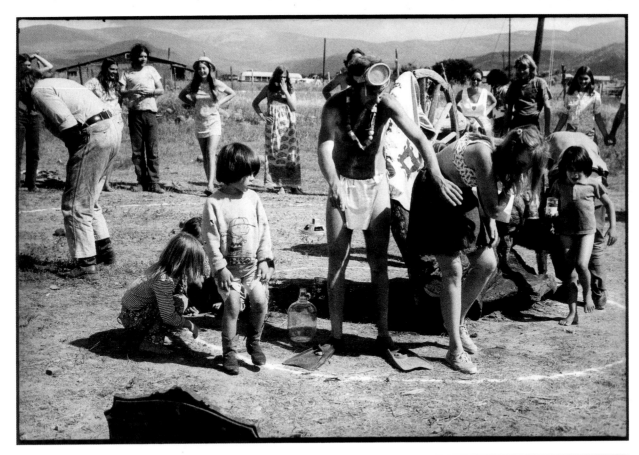

Frog race, Hog Farm,
Llano, New Mexico

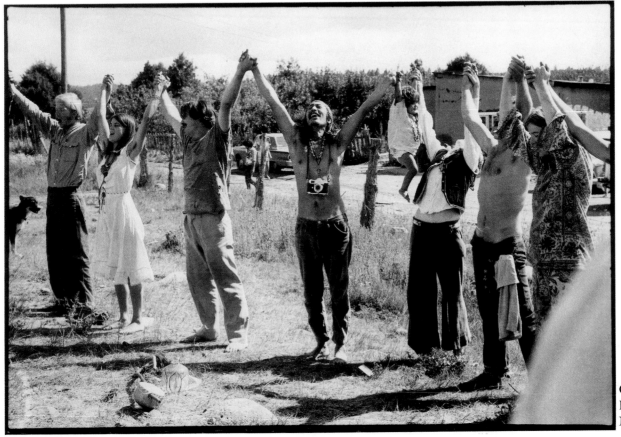

Gong Bong at the
Hog Farm, Llano,
New Mexico, 1969

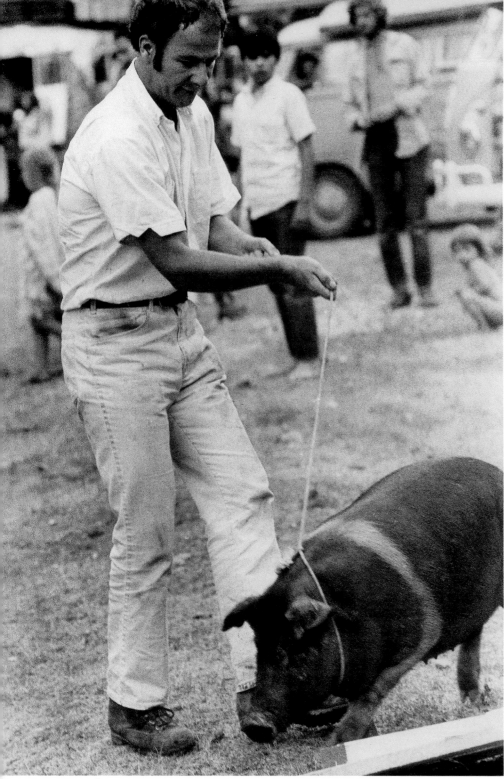

Hugh Romney trying to put Pigasus
into her truck

*Pigasus Pig is sort of a spinster. As a wee little pig she
thought she was a dog. Shared food and lodging with a lit-
ter of puppies. Expanded beyond doghouses, moved into a
pickup, toured the country and ran for president. A public
pig leads a lonely life.*

Wavy Gravy

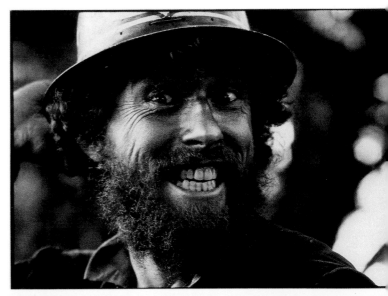

Paul Foster,
Prankster/Hog Farmer

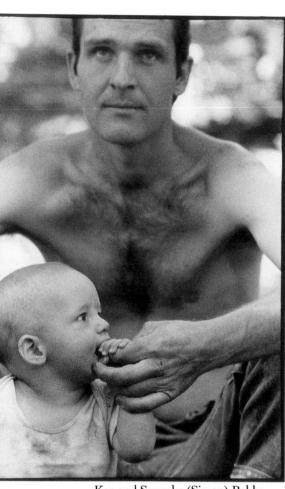

Ken and Squeeks (Simon) Babbs
Pranksters/Hog Farmers

Gretchen and Mouse (Casa) Babbs,
Pranksters/Hog Farmers

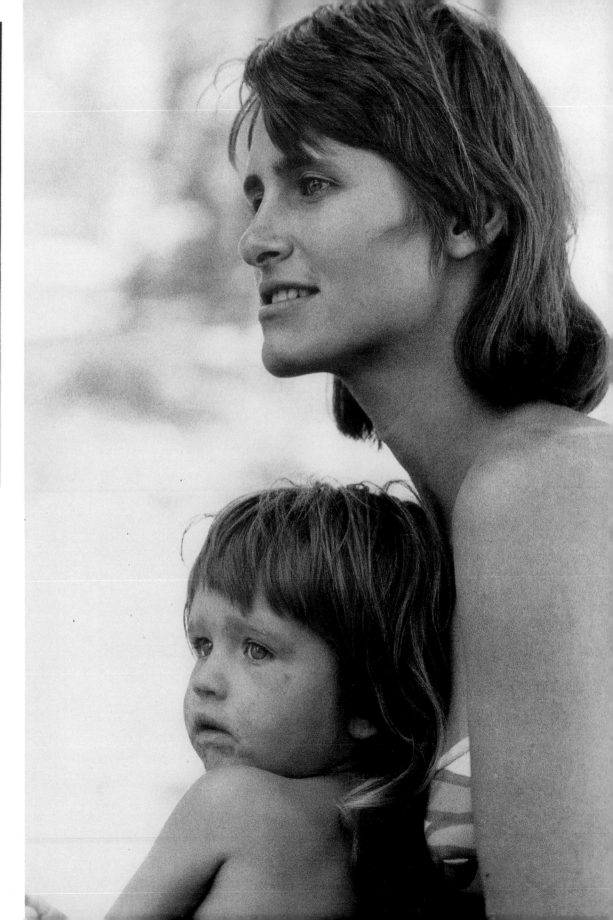

Nana, Eloysa, and Dede Hernandez with
Pilár Law at the Hog Farm camp, El Valle,
New Mexico . . . babysitting

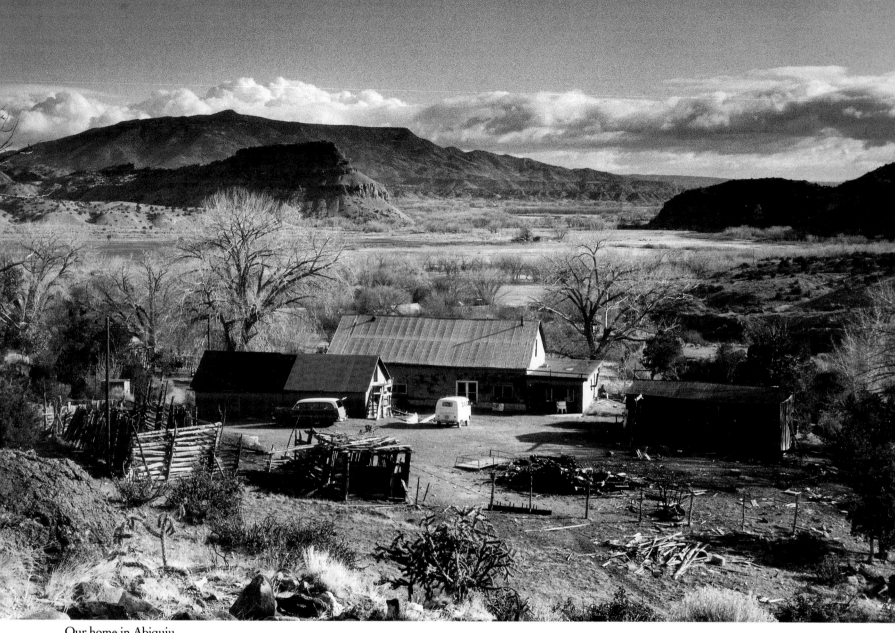

Our home in Abiquiu

The Roller

It was getting cold, and it was time for our group, the Jook Savages, to settle down some place for the winter. We found a big adobe house in Abiquiu not far from where Georgia O'Keeffe lived. All fifteen of us lived together, one room per family, and a kitchen and a communal room.

I can't say that I enjoyed that kind of living. It always seemed that the women ended up doing a lot more chores than the men. The men played music, smoked the herb, chopped wood and repaired vehicles. The lack of privacy was a test. Maybe it annoyed me that I had to be quiet while making love. But I got pregnant anyway, and soon after we all moved back to Los Angeles.

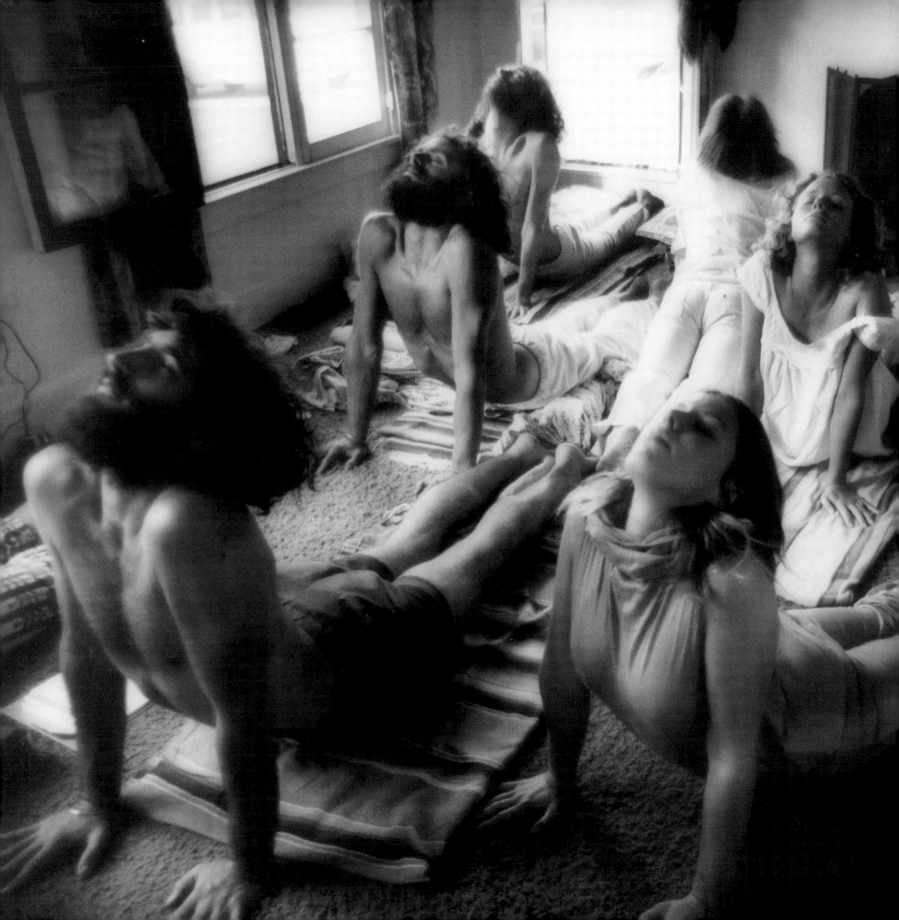

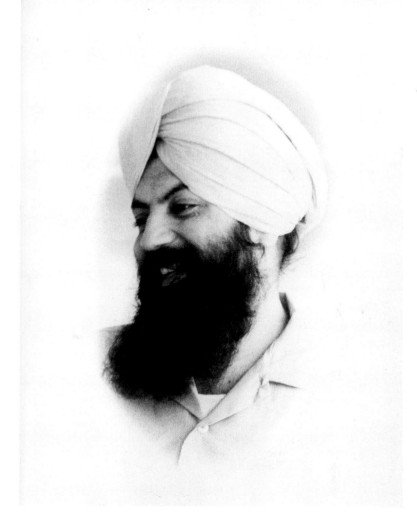

Because New Mexico had been so cold, it was good to be in Los Angeles despite the smog. We started to study Kundalini yoga with Yogi Bhajan, a very charismatic Sikh who had come from India. Jules Buccieri had met him and had sponsored him, giving him an ashram to teach, a car, and a house to live in. We took classes once, sometimes twice, a day and found out that "de breatht iss de tender charge of da dewine." We stopped smoking marijuana and started getting high on breathing. Enough of being potheads. Now we could be healthy, happy, and holy.

Above: Yogi Bhajan, East-West Cultural Center, Los Angeles, 1969. *Left:* Yogi Bhajan's sashim, Los Angeles, 1970.

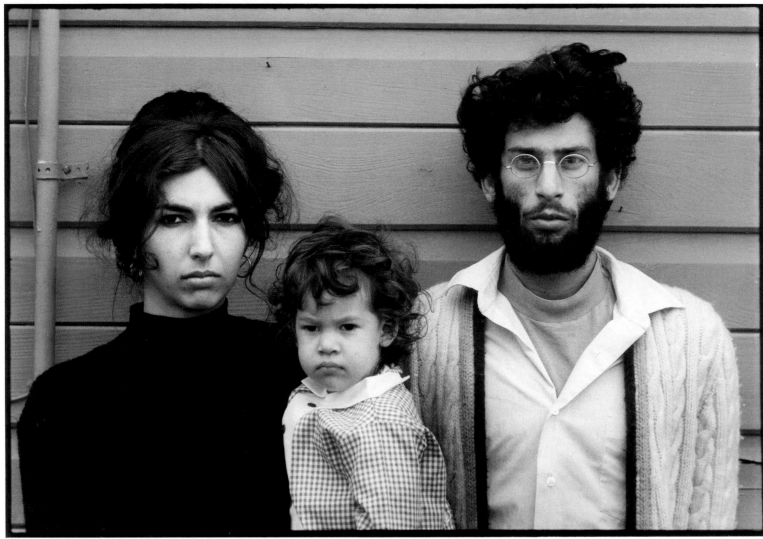

Nico, Mona, and Harvey Fox, students of
Kundalini yoga, Los Angeles ashram, 1969

Patio, Yogi Bhajan's sashim,
Los Angeles, 1970

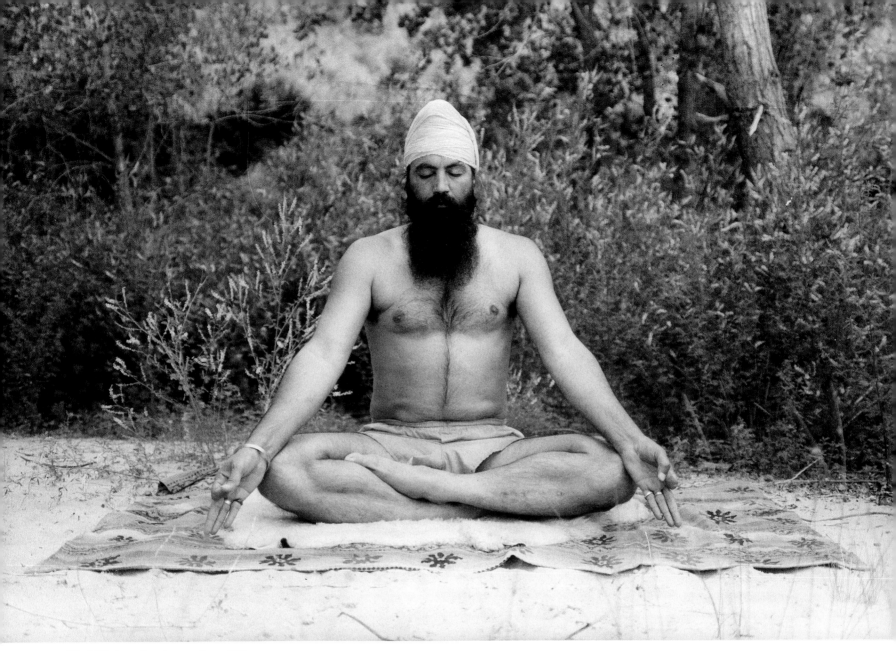

Yogi Bhajan, showing students 108 poses,
Embudo, New Mexico, 1969

It was a hell of a solstice. Even Ken Kesey showed up. He appeared in his truck with an empty tank of laughing gas and a full tank of gas gas and they claimed it was supposed to be the other way around, but we were real glad to see him anyhow, plus he got to re-union with his bus, which came all the way from Oregon, resurrected by David Butcovitch, so here we all are, maybe eight buses including Furthur and the Road Hog (maybe Son of Furthur) in Aspen Meadows high above Santa Fe. And for raw materials we sure got plenty buses and it's beginning to feel like a bus race. Kesey got a mattress on top of his bus. He always claimed the roof to be the Riviera and he is into some serious R and R with all these cases of beer that he is passing out with screw-on tops and nobody ever figured that the acid would be in the beer but here we go again, kids—an electric bus race.

I figure the safest way to do this is in heats, sending one bus out at a time, clocking them as they go up the meadow to the other end of this canyon, turn around and slide back home where we'd have some kinda finish line which would also be the starting line. But the next thing you know, when everything is stoned as a boulder, up pops Reno Kleen with a note from the state police. They want us to make an announcement, they are looking for a young couple named John and Mary who had been exposed to bubonic plague, the words ripple down the D.N.A. to all the other me and these that have shaked and quaked to the terror of plague, the black death, Jim! So I got this note that says bubonic plague and I don't know where it came from, and I kept looking at it and it kept sayin', bubonic plague, bubonic plague, bubonic plague. I show it to Kesey and he says, "Well, you sock it to 'em," so I say, "Well, folks, it's bubonic plague time and some folks named John and Mary have bubonic plague so let's find them and let's get them shot up." This started to bring everybody down. You can well imagine that the bubonic plague and the electric beer knocked the race right off the track, so we changed our contest and each bus is gonna look for John and Mary and the first bus to find them and shoot them up wins all this stuff that's important to us, that we really didn't wanna lose, like the silver bell on Furthur and the naked chrome Donald Duck that rode on the radiator cap of the Road Hog and the rooster with the rainbow feathers of the Just Bus and all these little whohaws and geegaws like the goat of Notre Dame, but our own personal family mojos, and we

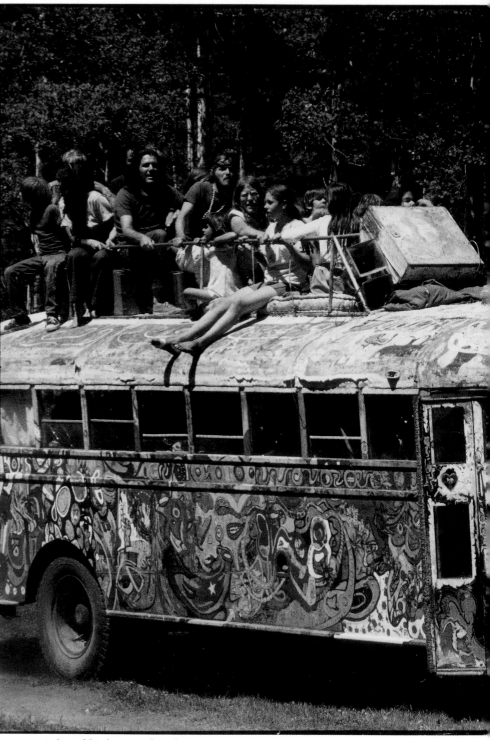

Ken Kesey aboard his bus Furthur during
The Great Bus Race

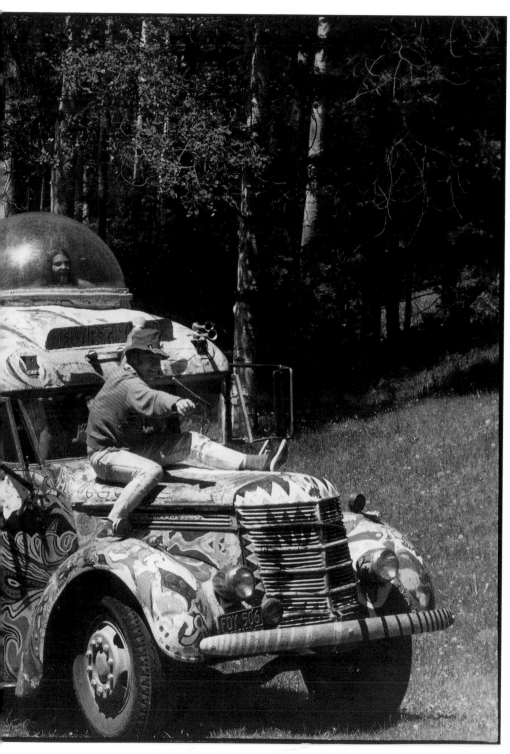

laid them all down on this table while the buses were warming up—vroomvroom, vroom!—and everything is set to go, it is set to go, it is really set to go and lightning flash this guy comes running up and says, "We found them, we found John and Mary, they're shot up." "Call off the plague," I said and I am pissed.

But the buses are still roaring and revving and there is no turning back. It's gonna be all together, once around the canyon, like mad steel dinosaurs breathing smoke, eight abreast and there's only room for three or four and nobody is givin' or slowin' but just goin' and goin' and I am clingin' to the roof of the Just Bus, screaming, "careful, we are chromosome damaged" and "no brakes" and Kesey is so cool just sittin' there on Furthur's temple sippin' electric beer and on my left here comes Erica, she's drivin' the Hospital Bus, fortunately they had removed the wounded. She had this mad crazy glazed look in her eyes and there are these howdy folks that just stepped out of their 90-dollar Abercrombie and Fitch pup tent to investigate the ruckus and just in time because Erica sliced it in half with her bus, you understand.

Next we swing by Yogi Bhajan, foot swami, and his breathing class. He nods and salaams and we just miss him. Whiterabbit suddenly can't go or he can't make the turn or has run out of gas, but he's an obstacle. There is this big White Bus, the Queens Midtown Tunnel of Love is in the way and everybody is having to try and get around it. Just another obstruction exercise. The Road Hog and Furthur careening like crazy and I remember I am screaming, "Be careful, be careful," and Kesey is screaming "Press on!"

From now on it's all downhill without brakes and we're gunning for the finish line closer and closer and standing right there is a kid who is frozen, like he can't make a move with all those buses downpouring upon him, and somebody leaps—I think it was Jerry Lamb—just leaps out of the crowd and grabs up that kid and rolls him to safety while bus after bus comes tumble and rumble to the spot where he was and he wasn't—Whew!!! Another miracle. Nobody gets hurt and according to Kesey, "in Aspen Meadow above Santa Fe, the Great Bus Furthur lost her silver bell to the Great Bus Road Hog in the First Annual Summer Solstice Great Bus Race."

Wavy Gravy
from *The Hog Farm and Friends*

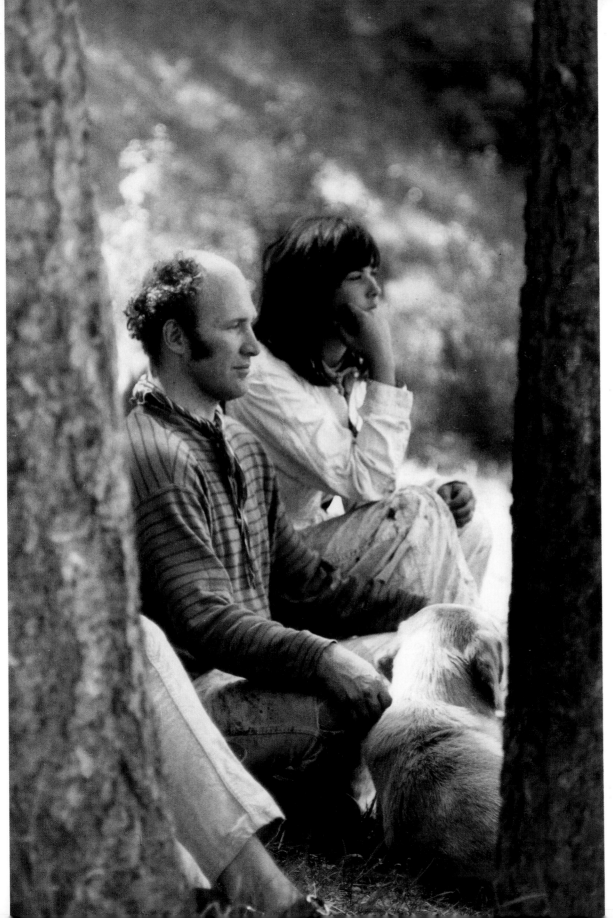

Ken Kesey and friend
watching yoga class

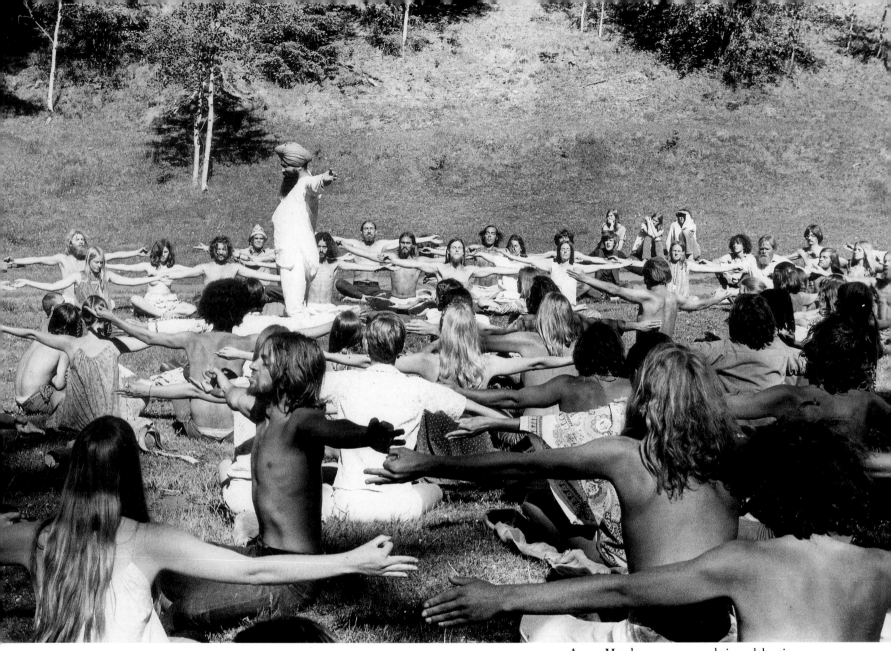

Aspen Meadows, summer solstice celebration,
Tesuque Indian reservation . . . Yogi Bhajan
teaching Kundalini yoga. Tom Law and I were
married that day along with several other couples.
Bhajan performed the ceremony.

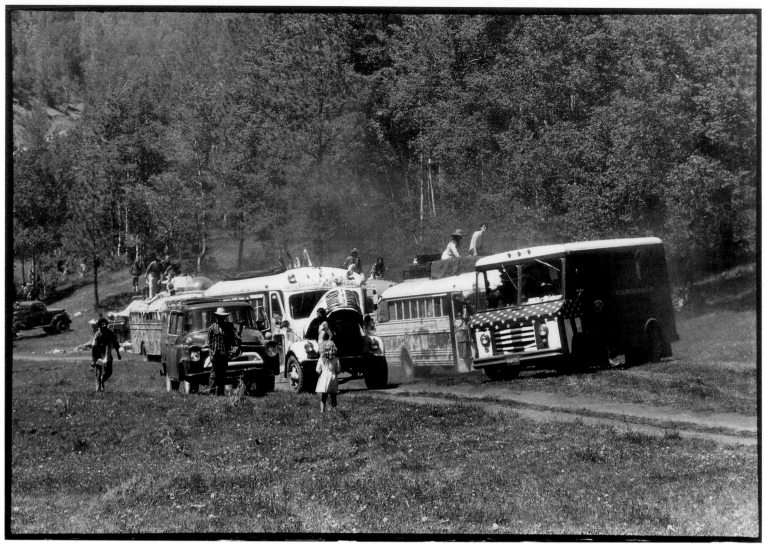

The Great Bus Race, summer solstice, Aspen
Meadows, 1969

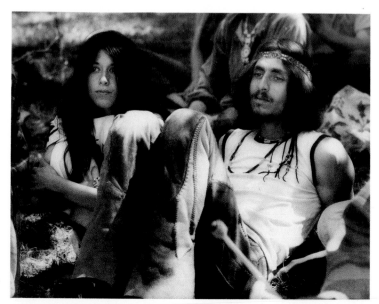

Cindy and Don Gallard,
summer solstice

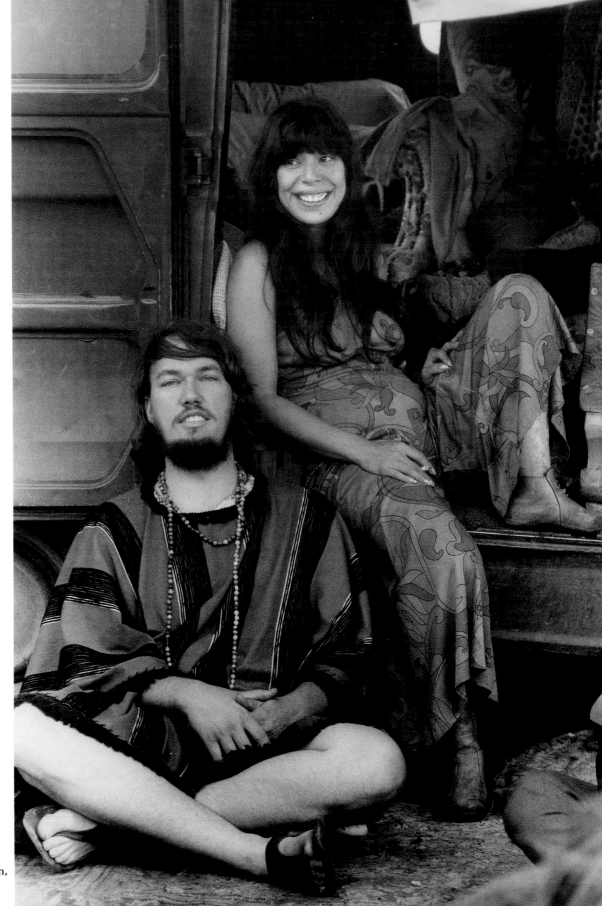

Gary and Ondia Wheaton,
summer solstice

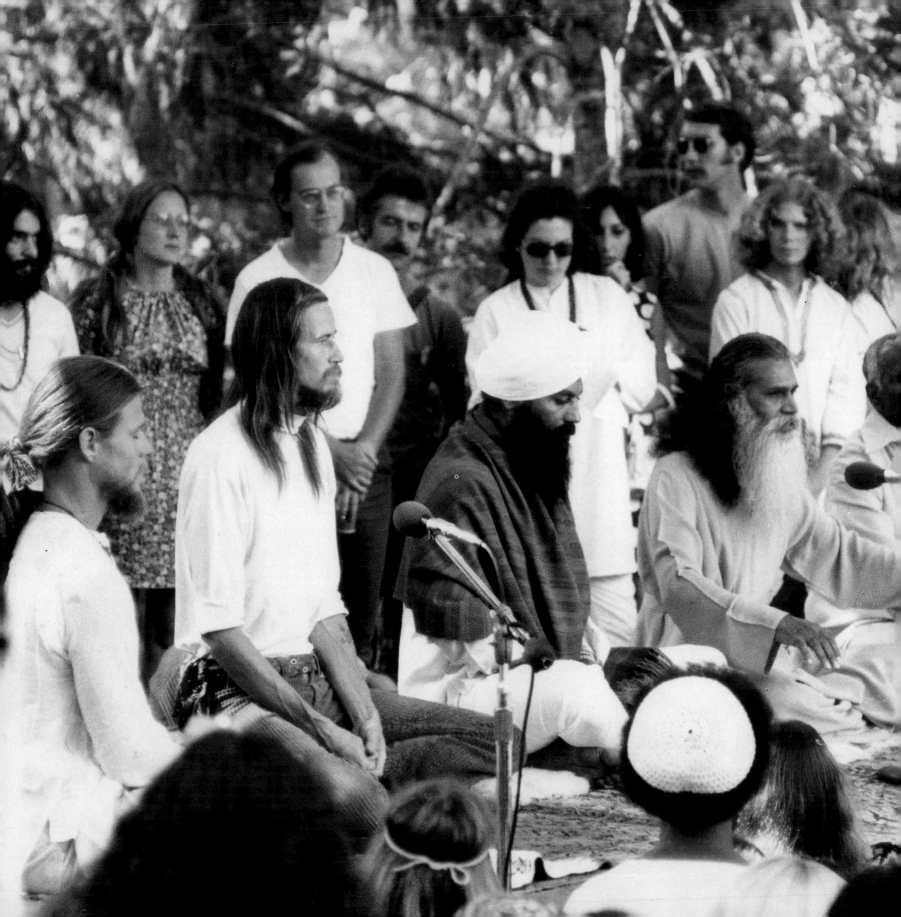

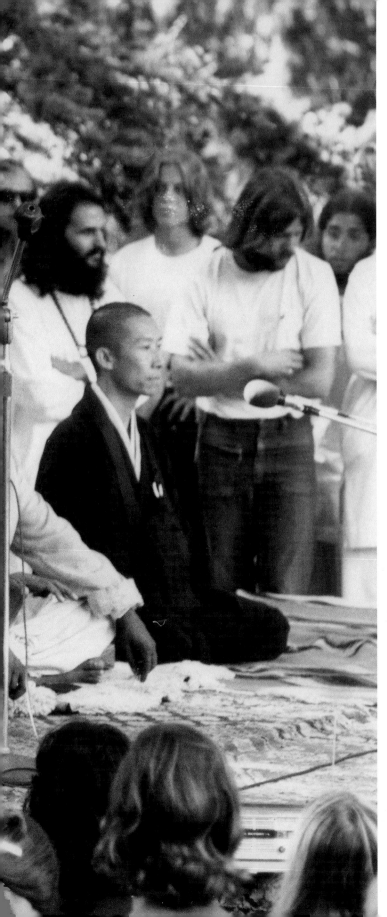

In June 1970 in the quadrangle at the University of Colorado at Boulder, some three thousand shining aspiring faces listened to words and wisdom of Swami Satchidananda, Yogi Bhajan, Steve Gaskin, Bill Quan-roshi, and other spiritual heavies at the Holy Man Jam. This was probably the first large conference of its type to take place. It became the prototype for the myriad of spiritually oriented New Age conferences which have followed since.

Alan Oken

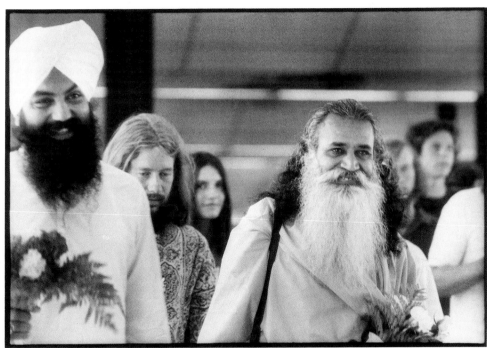

Yogi Bhajan meeting Swami Satchidananda
at the airport

Tom Law, Steve Gaskin, Yogi Bhajan, Swami Satchidananda, unidentified man, Bill Kwong-roshi, Holy Man Jam

Students, Holy Man Jam

"Come to Colorado with me and you will leave an astrologer," Yogi Bhajan said one afternoon in New York City. "Do not charge any money. Take everyone who comes to you and read for them for twenty minutes," he went on in his booming and penetrating voice. During the week of the Holy Man Jam I taught astrology every morning to a crowd that gradually increased from 300 to 3,000 people. Then from noon till 5:00 P.M. I read horoscopes, 200 of them, and the tent that Yogi Ji had set up for me began to fill with breads, bowls, beads, crystals, and other offerings

Alan Oken, astrologer, Holy Man Jam,
Boulder, Colorado, 1970

*that people brought to me as gifts ... and the evenings after
the readings I went out into the crowd and gave away my
gifts and made many friends.*

*Lisa and Tom Law invited me to their farm in
Truchas, New Mexico, outside Santa Fe, and after the Jam
a caravan went out there and stayed for a week or so. I
came home to New York an astrologer and shortly after,
took my family back to New Mexico where we have lived
every since.*

Alan Oken

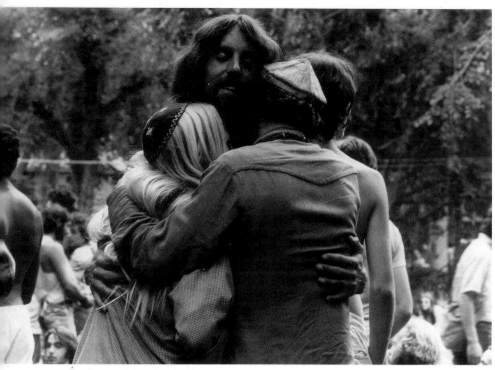

Holy Man Jam inspiration

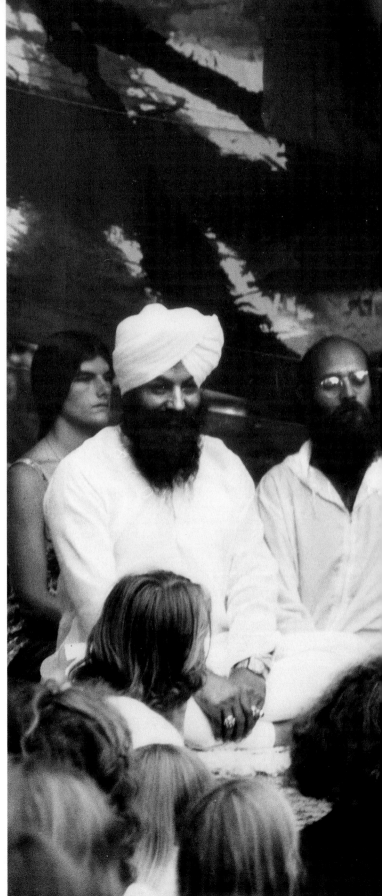

Yogi Bhajan, Steve Gaskin, and Tom Law, emcee, discussing how to perform Karma yoga

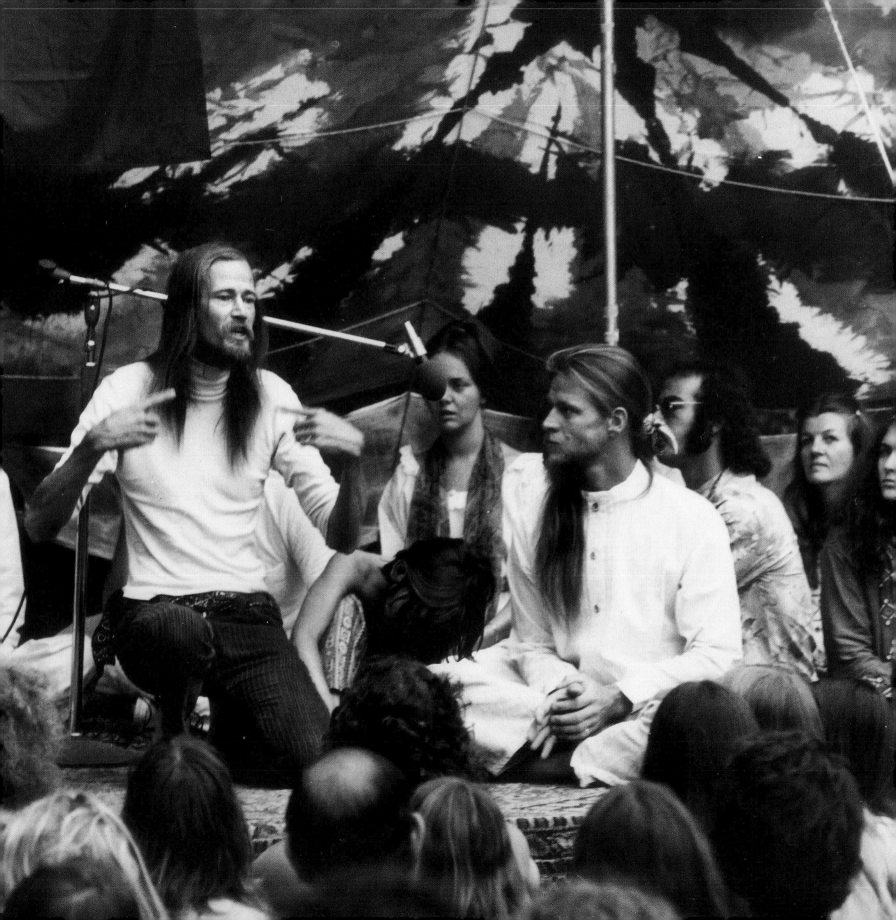

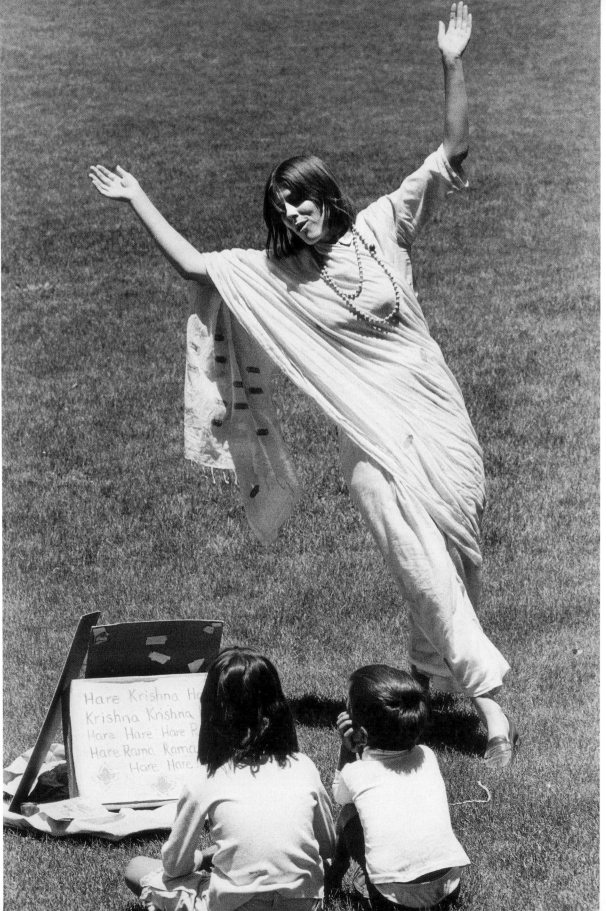

Hare Krishna student
chanting and dancing,
Santa Fe, 1969

Bonnie Jean (Jahanara) Romney, Hog Farm police
commissioner, Espanola, New Mexico, at a gas and
candy fill-up

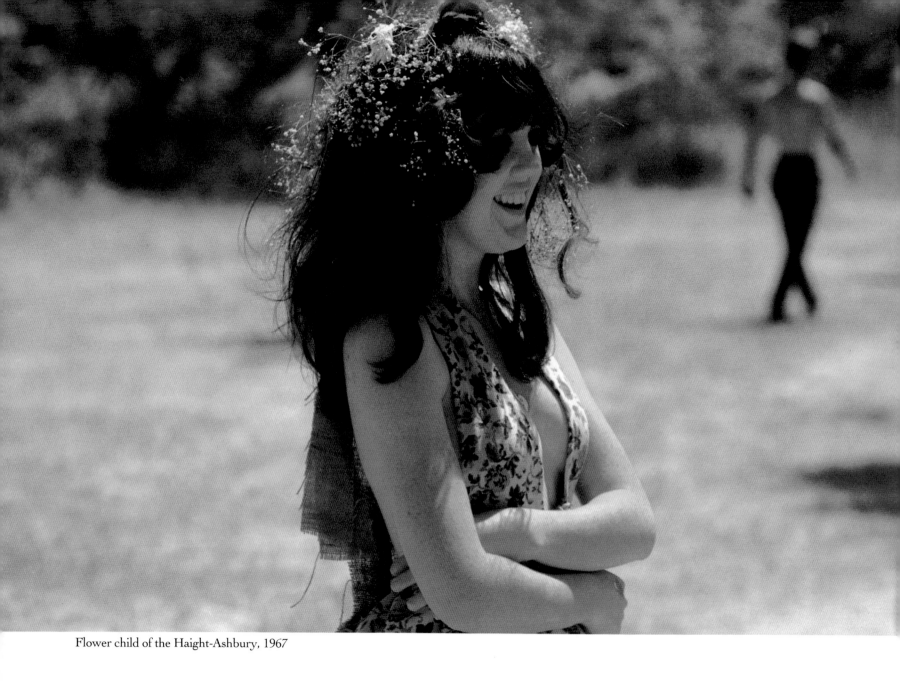

Flower child of the Haight-Ashbury, 1967

Front page, San Francisco, 1967

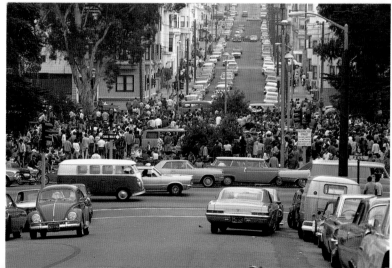

The Panhandle,
Haight-Ashbury, 1967

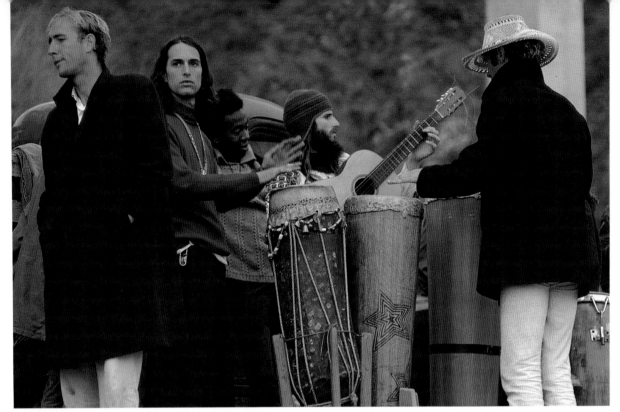

Lime Kiln Creek Love-In (Garry Amente on drums)
near Big Sur, California, 1967

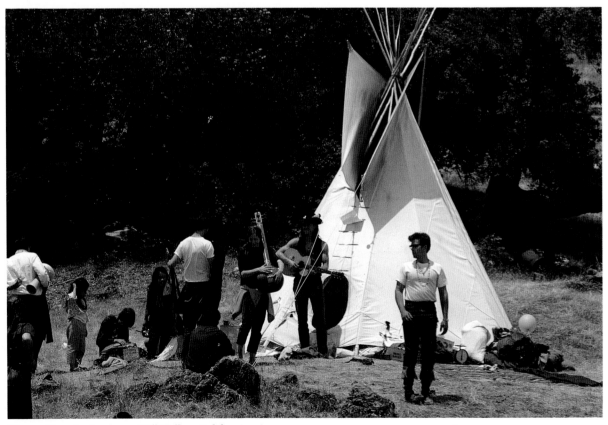

Mount Tamalpais, above Mill Valley, California,
Fantasy Fair Music Festival, June 10, 11, 1967

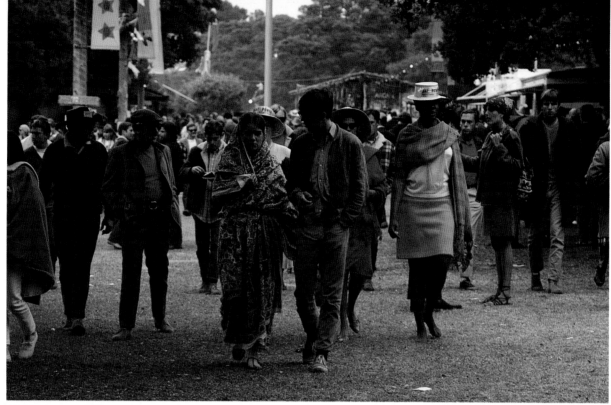

Music, love, and flowers, Monterey Pop, June 16, 17, 18, 1967

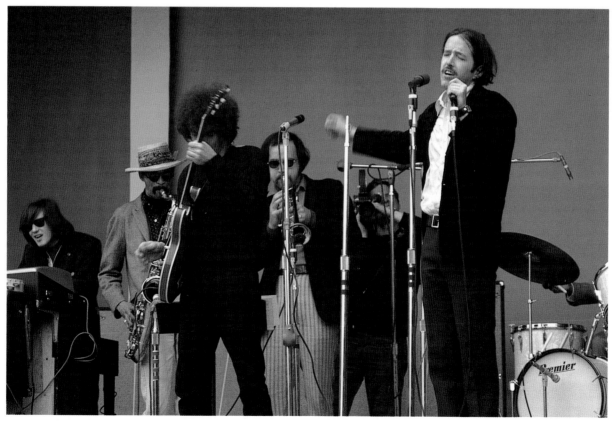

Butterfield Blues Band, D. A. Pennebaker on camera

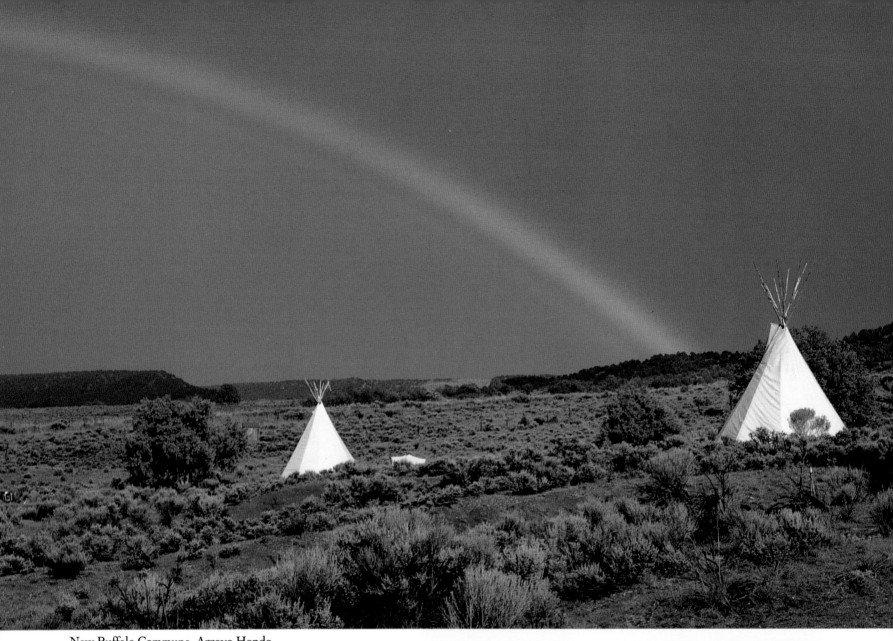

New Buffalo Commune, Arroyo Hondo,
New Mexico, August, 1967

Evan Engber,
amanita muscaria

Savage Soup, Abiquiu, 1968 (Pilár Law)

Ron Caplan, David Gordon, Max Finstein, New
Buffaloers

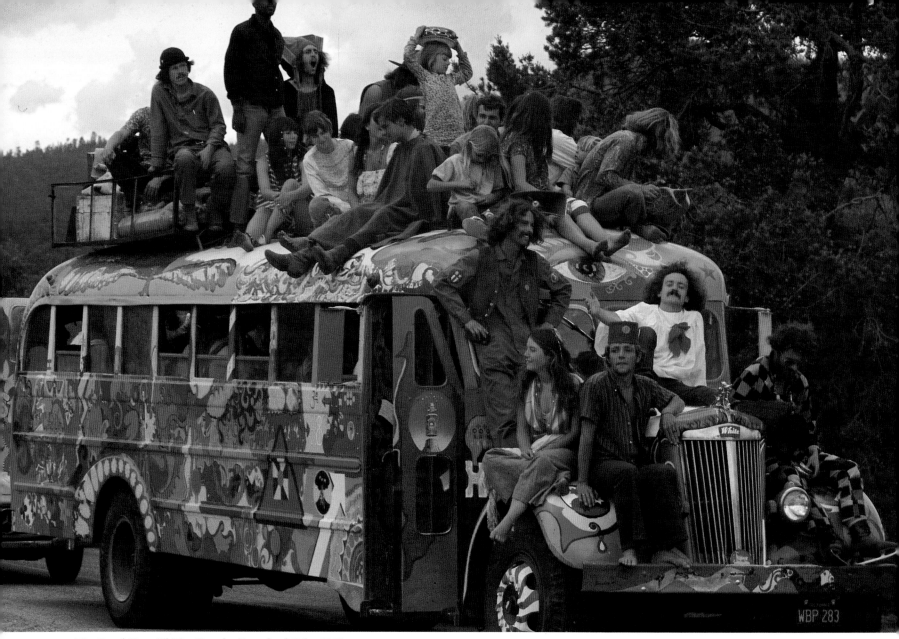

The Road Hog, El Rito Parade, Fourth of July, 1968

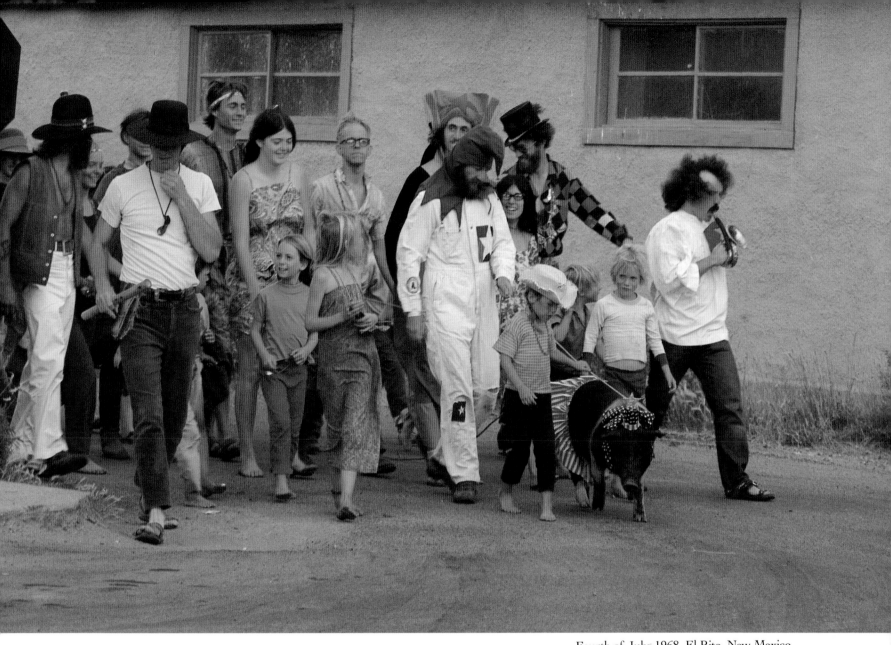

Fourth of July, 1968, El Rito, New Mexico

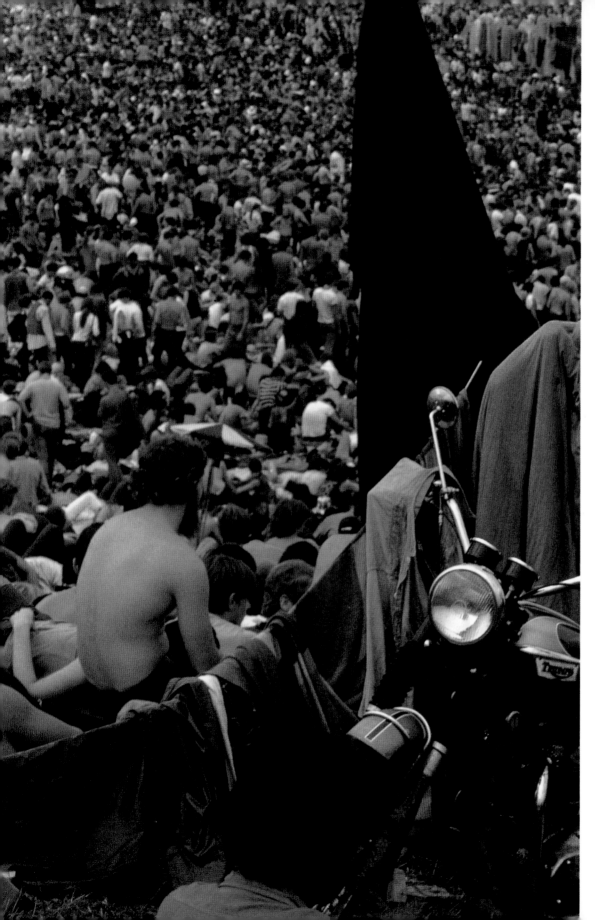

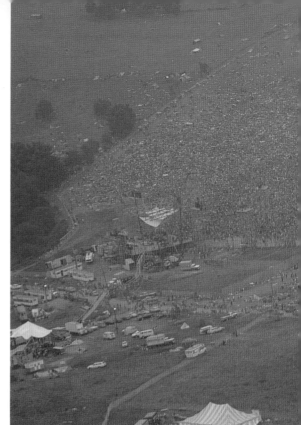

Woodstock Music and Art Fair,
An Aquarian Exposition

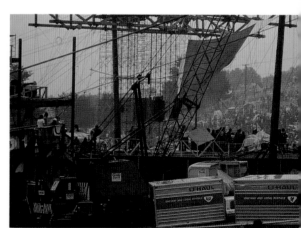

Stage, Woodstock

Woodstock

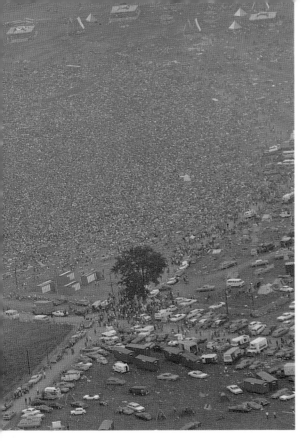

Baby race, Hog Farm camp, Woodstock

The calm before the storm at Woodstock

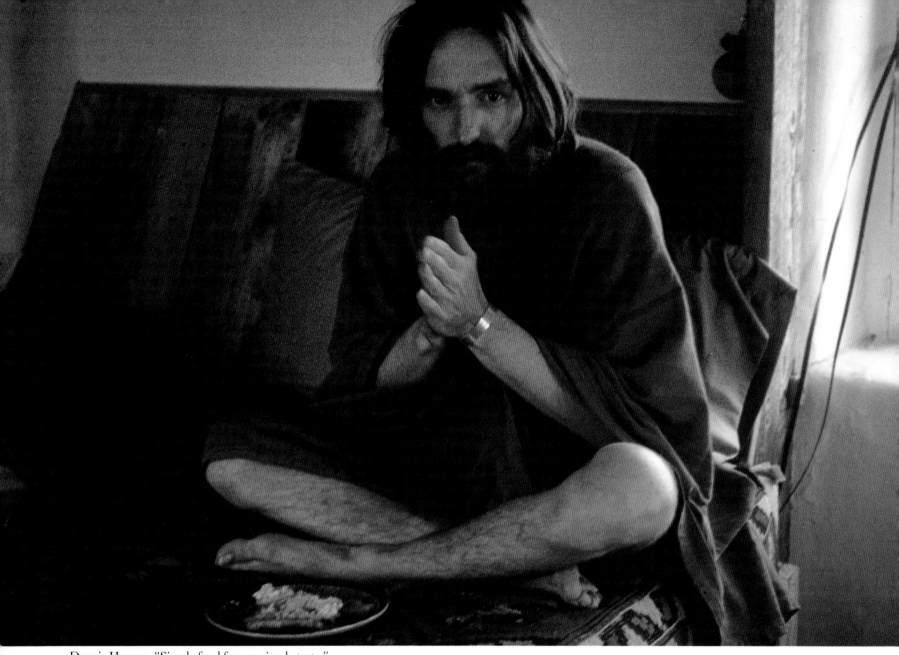

Dennis Hopper. "Simple food for our simple taste."

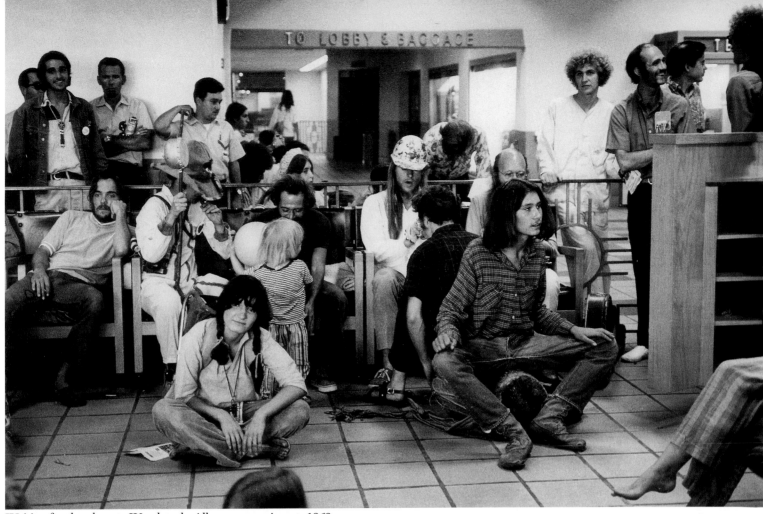

Waiting for the plane to Woodstock, Albuquerque airport, 1969

Loading the tepee poles aboard our jet to New York

At the Aspen Meadows Summer Solstice Stanley Goldstein had asked all of the Hog Farmers and Jook Savages if we would handle the coordination of the campgrounds at a festival that was to be called the Woodstock Music and Art Fair.

Having agreed, our party of about eighty people turned up on the assigned day at the Albuquerque International Airport to await the arrival of the jet the organizers had sent down from New York to take us to the festival. The bathrooms were full of people taking slugs of wine laced with LSD from a bota bag.

We were met in New York's Kennedy Airport by many reporters holding big lights and big cameras. They wanted to know if we were handling security at Woodstock. A reporter asked Wavy what he was going to use for weapons, and he said, "Seltzer bottles, seltzer bottles and cream pies."

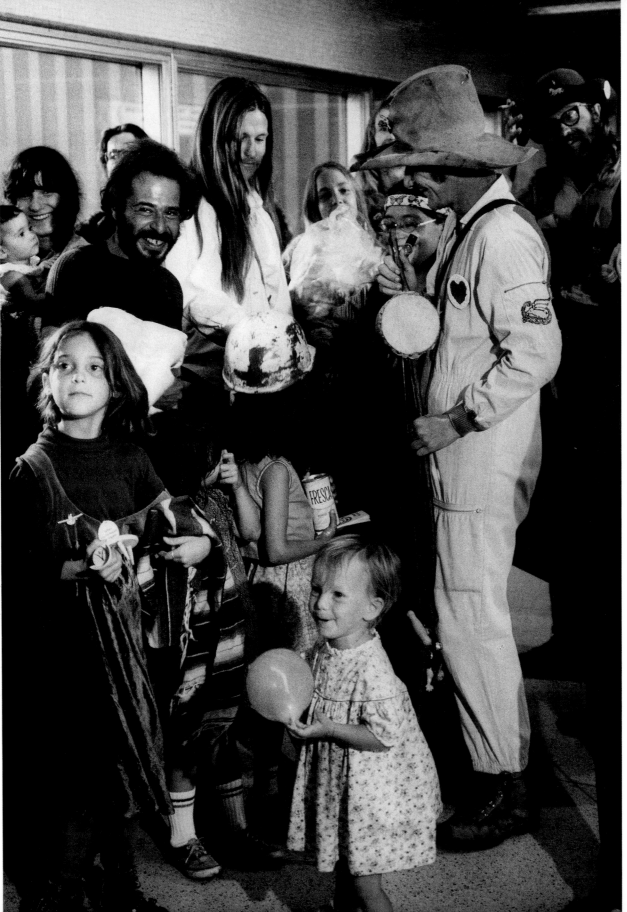

Arrival at airport

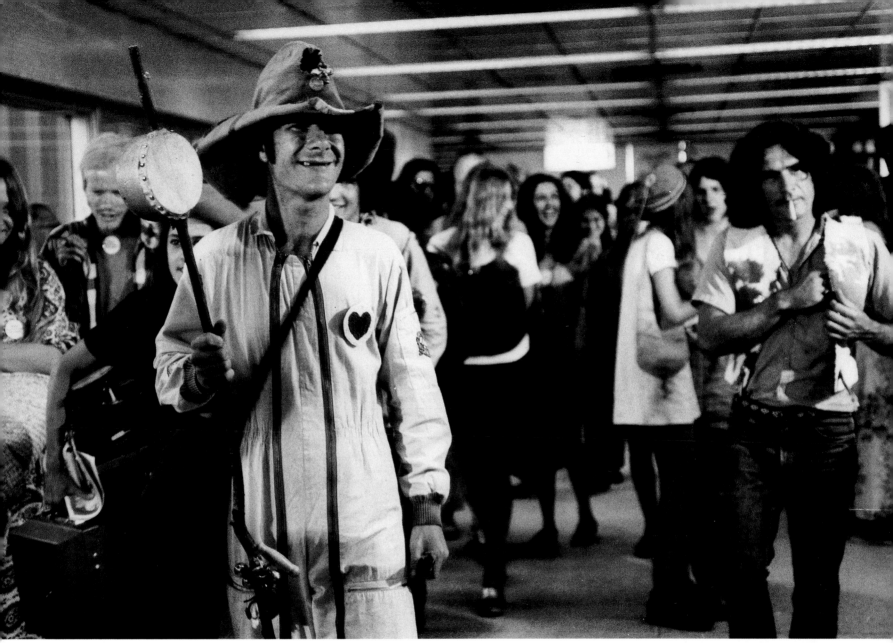

Wavy Gravy, Hog Farmers, Jook Savages,
and friends arriving at Kennedy airport on
the way to Woodstock

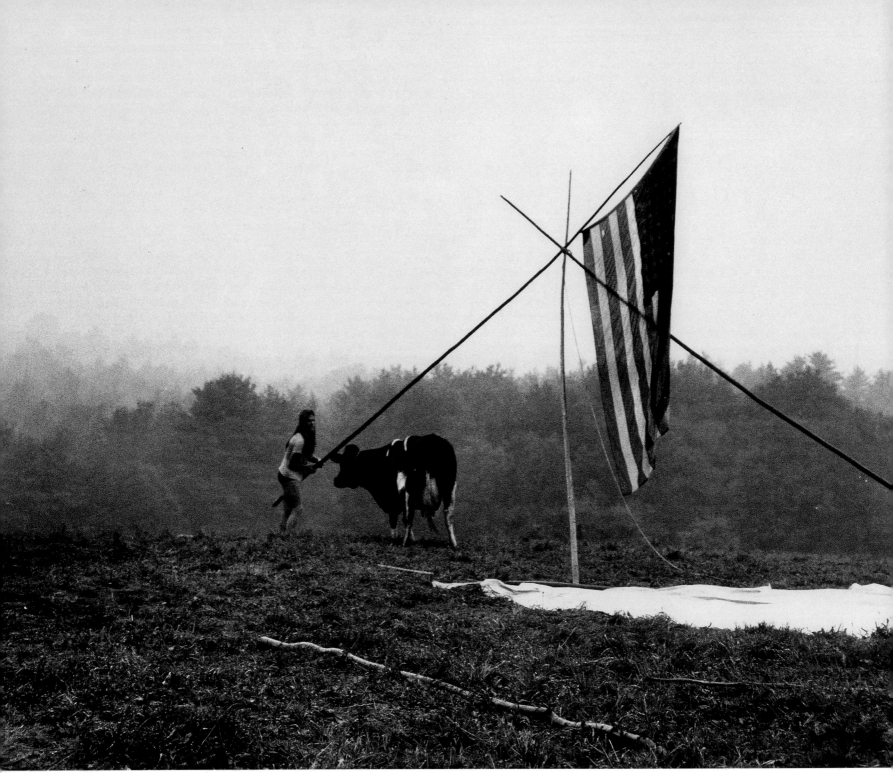

My husband, Tom Law, putting up tepee at Woodstock

We were whisked off to White Lake in big comfortable buses and made camp with members of our crew who had arrived earlier, having driven from New Mexico in buses loaded with supplies. We had nine days to put together the free stage, medical tents, free-food kitchen, serving booths, and information centers and to set up the trip tents for those needing to escape from too much noise, lights, people, and rain.

We would all meet in the mornings to decide what we would do for the day. The advance group had gotten together some aluminum pots and pans and a kitchen and were now feeding us all. I was on this big trip about how aluminum can poison you if you cook with it and decided at that moment to join the cooking crew.

We got this big flash! The message was that the free kitchen needed to be real big. I mean gigantic. There were going to be a lot more people at this festival than anyone had expected, and now was the time to prepare for those hungry souls out there who didn't have enough food with them, nor enough money to buy any.

Peter Whiterabbit volunteered to be my assistant, truck driver, and guide in New York City (where I had been only once in my life). I went to the trailer where they said I could get money, and I persuaded John Morris to give me $3,000, a meeting John says he remembers vividly to this day. Then we were off to The Big Apple. I was six months pregnant with my second child, and I thought I was going to lose him those three days, pounding the pavement looking for the perfect stainless-steel bowls, pots, and utensils. But it was fun going into a store and asking for 1,200 pounds of bulgur wheat and 1,200 pounds of rolled oats and two dozen 25-pound boxes of currants and 200 pounds of wheat germ and 5 kegs of soy sauce and 5 kegs of honey.

I ran out of money real fast and decided to hit up the downtown festival office for another $3,000. They gave it to me, just like that! We bought a giant onion cutter and a lot of Chinese cleavers. Now, I thought, where are we going to put all this chopped food? So we purchased 35 plastic garbage pails that worked just dandy. I figured that we would feed some 150,000 people, so I bought 130,000 paper plates and spoons and forks and about 50,000 paper cups with the pointed bottoms, like those you use with bottled-water machines. While roaming around Chinatown, I bought a jade Buddha for good luck and to keep the kitchen crew happy and healthy and blessed.

After three days of shopping, Peter and I had filled up the truck with supplies and some local folks who needed a ride to the festival site. Finally, late in the evening, we headed for home. Peter exhausted, crashed out, leaving me to drive the truck. I was chewing ginseng root and doing the breath of fire, with my head out the window to stay awake.

We set up the kitchens and got everything cooking, and out of nowhere came ten or fifteen volunteers at a time, cooking and having a ball. It was beautiful to see. All we had to do was to keep the vegetables and fruit coming.

Our farm in Truchas

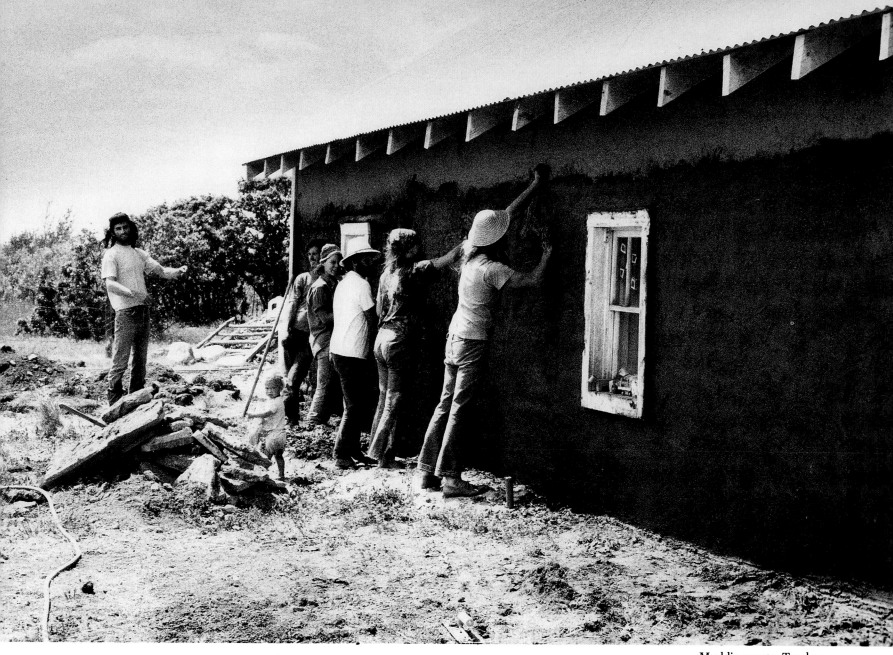

Mudding party, Truchas

t was time to settle down—we needed a nest to have our
second child. We also wanted to try our hand at farm-
ing and raising animals. Tom and I found a piece of
land in Truchas, New Mexico, with a house, garage,
horse, and barn. His benevolent brother John Phillip
Law bought it and we called it home. The back-to-the-
land movement was in full swing, and the countryside
was populated with small groups of dropout hippies
from the West and East coasts.

On October 28, 1969, Solar Sat Baba was born,
with his father delivering and a friend, Ruffin Cooper,
picked up from the Woodstock festival, helping.

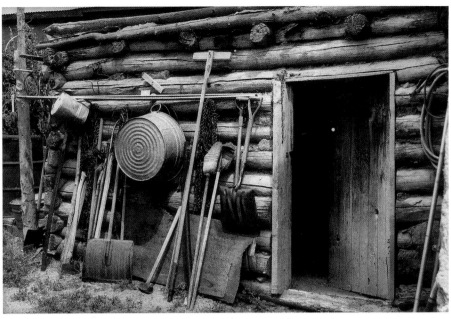

Liberato Vigil's shed. Our relationship with
the older people of Truchas was good. They
were glad to have people come and stay who
would work the land and raise animals.

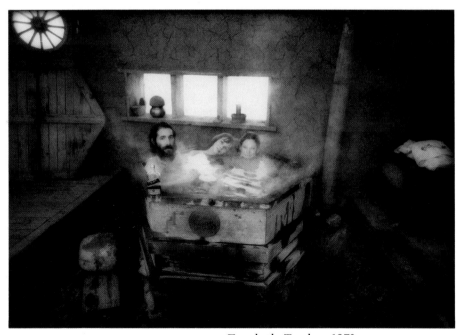

Furo bath, Truchas, 1970

Tommy Masters teaching Prince to harness,
Truchas

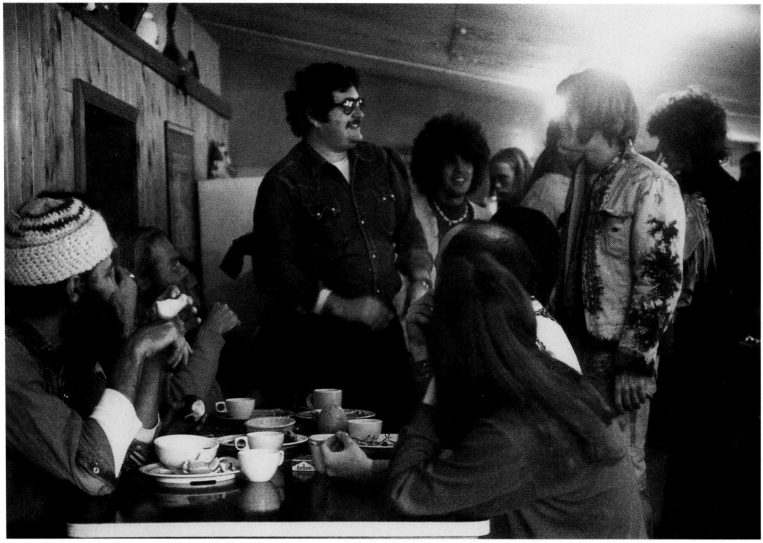

Reno Kleen, Tom Watson, Richie Moonchild,
Carl Gottlieb, Cyrus Faryer, John Sebastian,
and Michael Lang. Sympowowsium. The I
Ching read "the turning point" for the throw
for the meeting.

When Baba was three days old, Tom put on a Sympowow-
sium in the Jemez Mountains for people interested in
organizing festivals that neither ripped off the crowds
nor the entertainers. Michael Lang, John Sebastian, Ken
Kesey, Ken Babbs, Paul Krassner, Milan Melvin, Carl
Gottlieb, Don Hanley, Peter Yarrow, Michael Butler,
Leigh French, and many more showed up to discuss
proper outhouses, water supplies, and medical facilities.
Even with a five-day-old baby, I was toting along my
Nikon, and with my baby at the breast, I was shooting
the events as they unfolded.

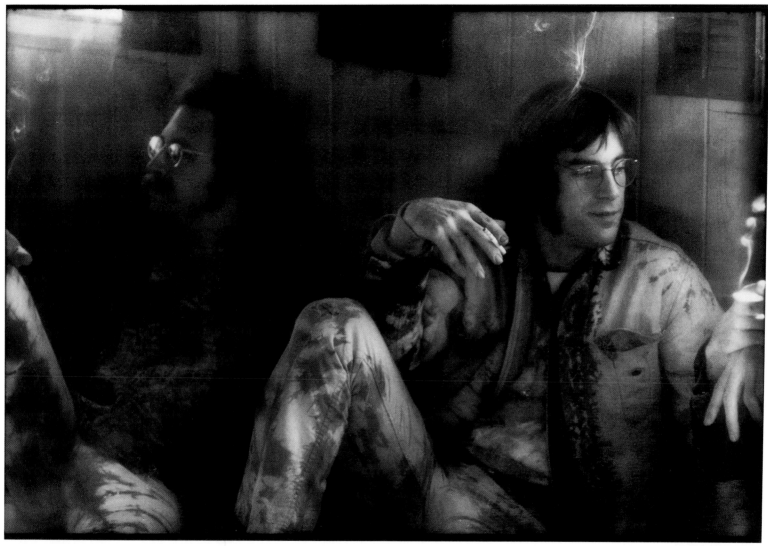

John Sebastian

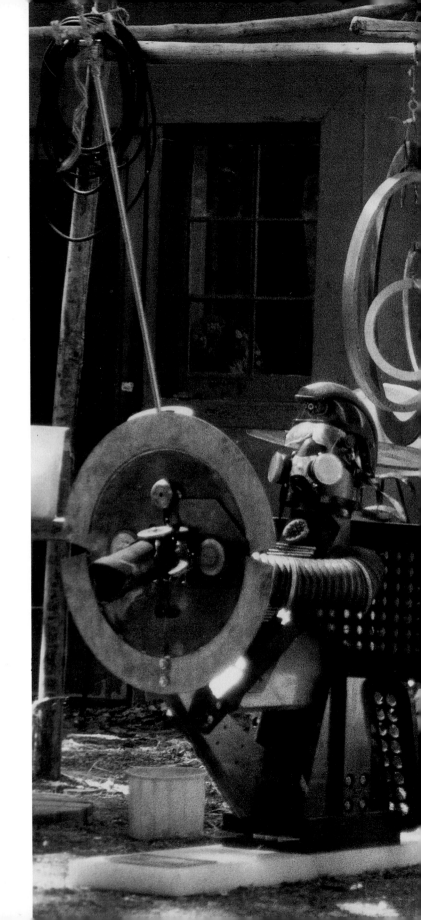

*Tony Price is one of the most fascinating, creative people
I have ever met. His commitment as an artist is extraor-
dinary. What he did with the materials from Los Alamos
redeemed them somehow. One gong was made out of the
warhead of an A-bomb. He had hammered into it the
Great Mandala of the I-Ching. Also, I remember that
huge combination xylophone/wind chime instrument
called Maya Song that was out in his field in El Rancho.*

Howard Hessman

Tony Price and Tom Law playing the atomic gongs with
Revelations Nine in front. All materials from the
weapons energy system at Los Alamos, birthplace of
the Bomb, El Rancho, New Mexico, 1970.

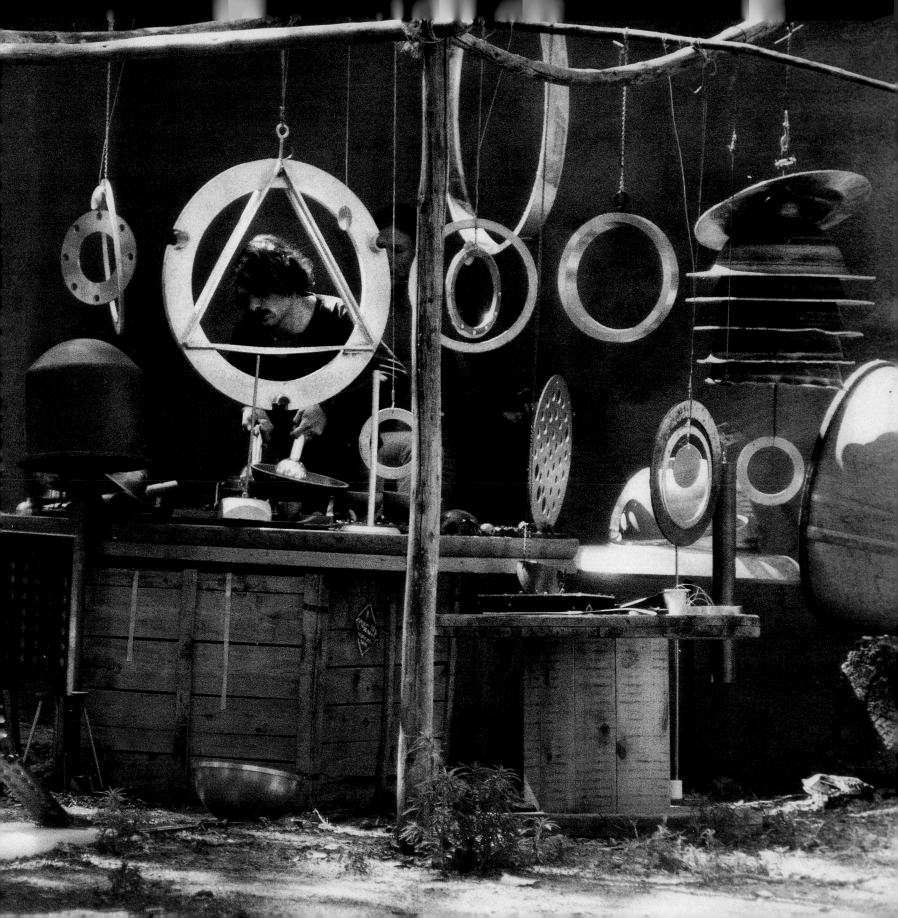

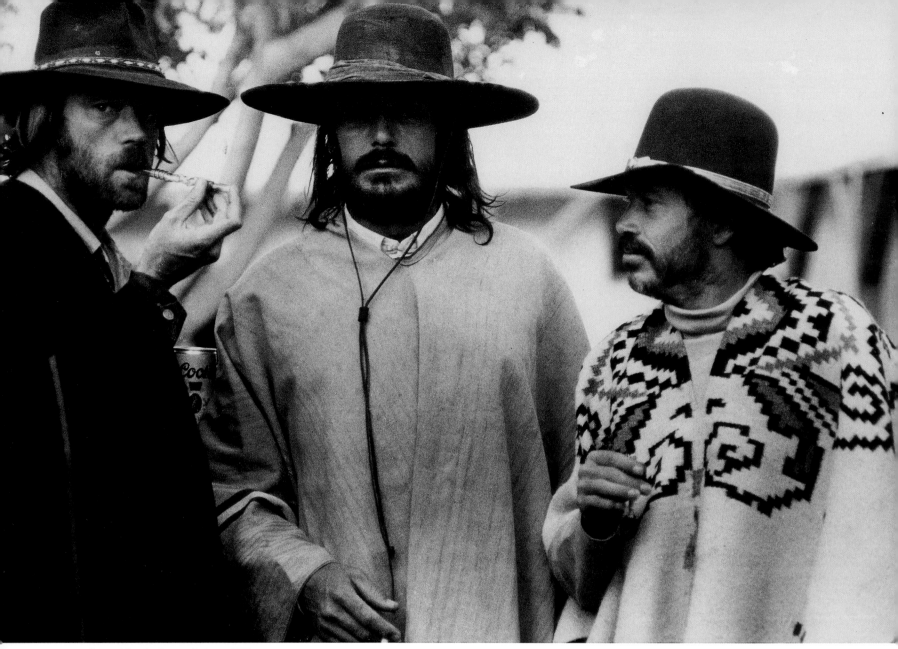

Ted Markland, Owen Orr, and Warren
Oates during filming of *The Hired Hand*,
Warm Springs, New Mexico, 1970

Dennis Hopper in his editing room at the Mabel Dodge
Luhan house in Taos

While Peter Fonda was filming *The Hired Hand* at Warm
Springs and the San Juan pueblo, Dennis Hopper was
editing *The Last Movie*, shot in Peru, in the Mabel
Dodge Luhan house in Taos. I visited Dennis quite
often and gave him massages. I always found the house
full of an international collection of interesting people:
musicians, studio executives, filmmakers, beautiful
women, writers, actors, artists, Indians, and gun-toting
cowboys. It was a salon like the old days in Paris or
Greenwich Village. Dennis moved from room to room,
giving each person special attention even if for a brief
moment, always returning to the editing room.

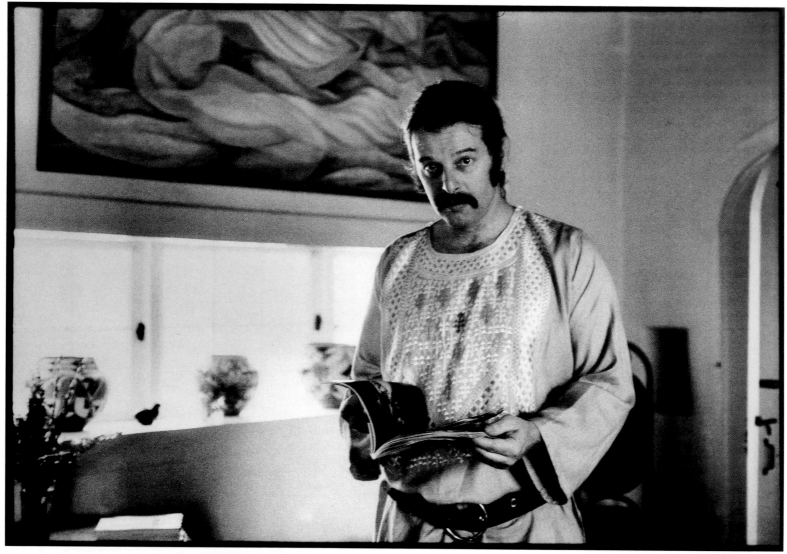

Alexandro Jodorowsky, director of *El Topo*, stopped by Taos to visit Dennis Hopper for a few days to see how the editing was coming of *The Last Movie*

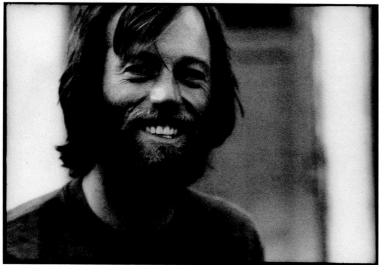

Peter Fonda,
director and star,
The Hired Hand

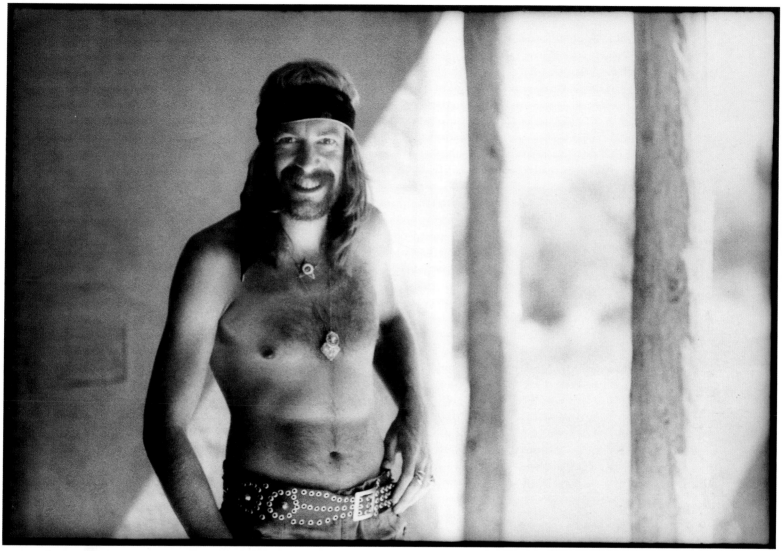

Howard Hesseman, actor, El Rancho,
New Mexico, 1970

I had shot Billy Jack *in New Mexico a few months earlier
and wanted to go back and see a little more of that country.
I had a strong desire to make up for that experience by
coming back and looking at Santa Fe and the area, sort of
do penance for what I had done to it by being in that movie.*

Howard Hesseman

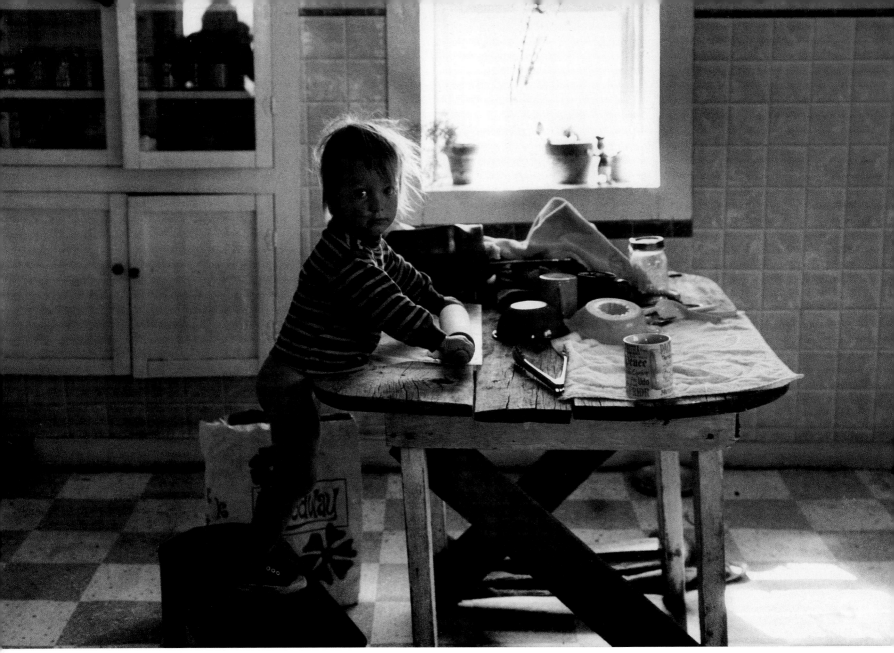

Pilár making chapatis in our kitchen, Truchas

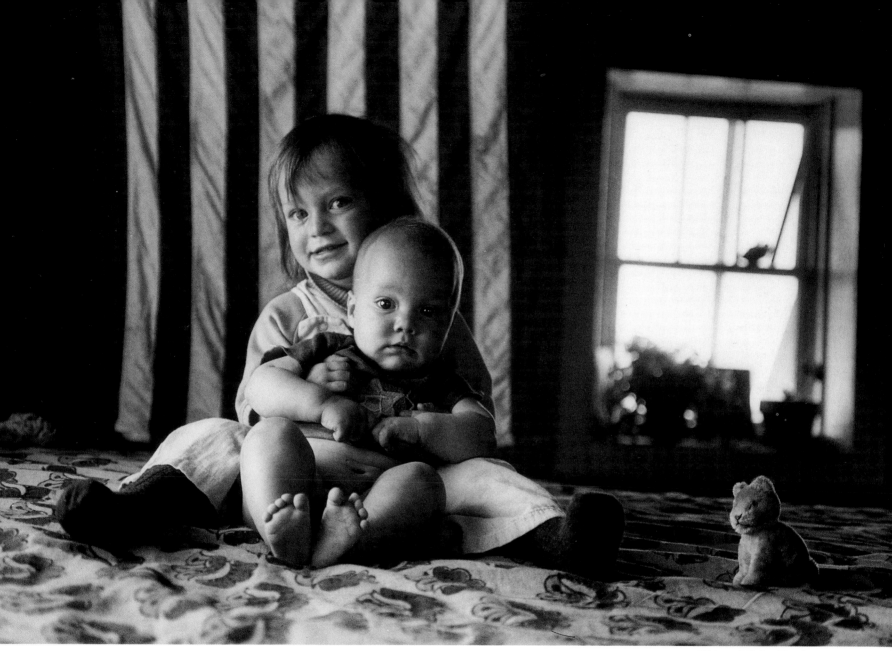

Pilár and Baba, Truchas

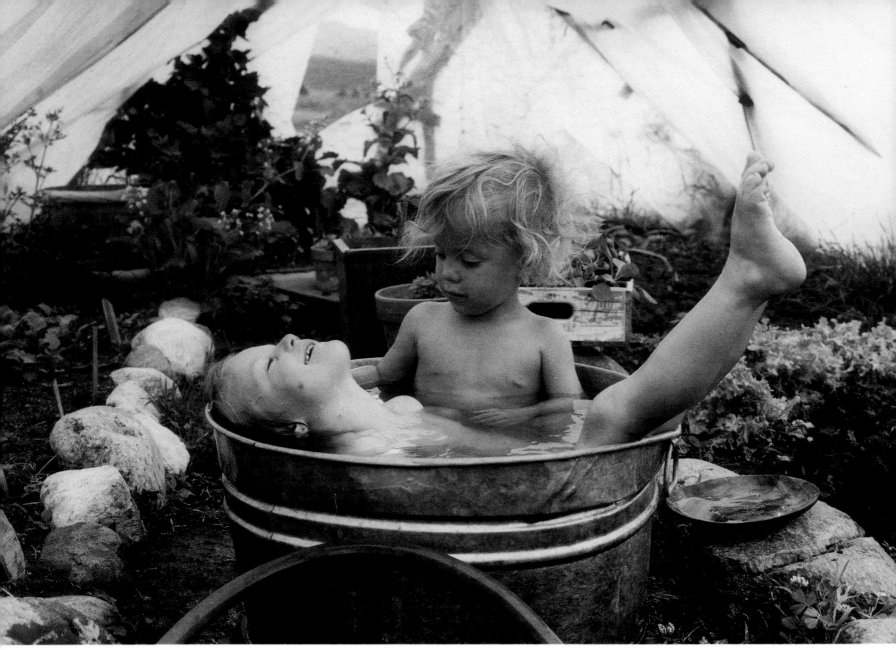

Pilár and Baba Law in greenhouse, Truchas,
1971

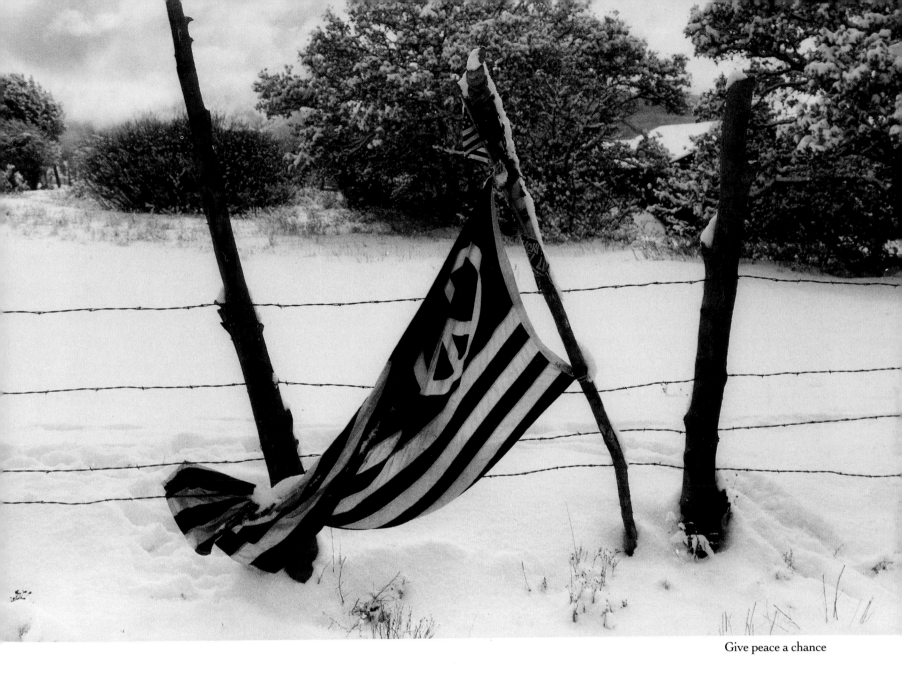

Give peace a chance

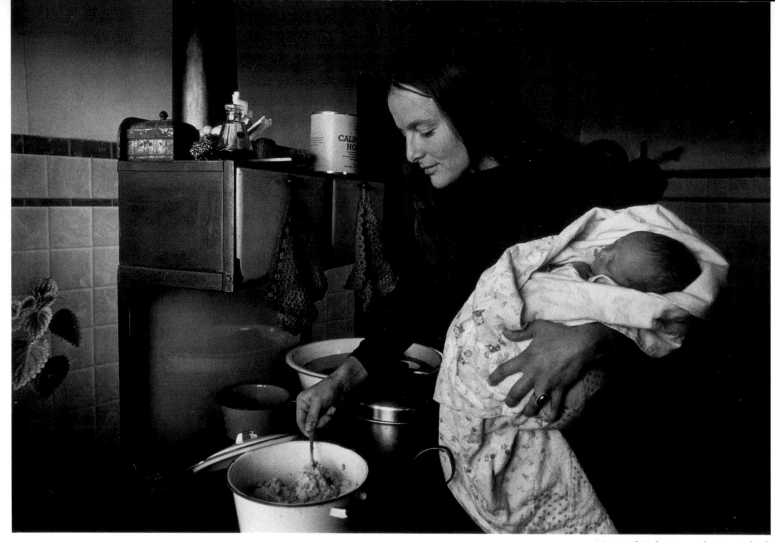

Lisa and Baba Law photographed
by Michael Mouney, 1969

ife magazine came to our house just after Baba was born in 1969 and did a story about alternative religious beliefs and lifestyles. By God, those who read the magazine came in droves looking for the answers to all kinds of questions: "What do I have to do to drop out?" "How can we do what you have done?" "Where is Timothy Leary?" "Would you give me some recipes for my commune cookbook?" Even Dylan came with a long-haired, barefoot Jesus freak wearing white robes. Jane Fonda came in black leather. Tom and Reno started a Beginning Basics course to help many of them. I slowly went mad with no privacy and having to shop and cook for everyone who dropped by with, of course, no money or food. Many of them still needed to learn to be responsible for themselves.

What sustained me was the knowledge that my relationship with the earth and with my children was what counted the most. I hung on to that belief. I had brought my children into the world with gentleness and that bound us together. Breast-feeding gave us love and security. Whole foods like fresh goat's milk, eggs, and home-grown fruits and vegetables gave their bodies a healthy start, and living close to the earth gave us a feeling of harmony with the planet.

I experienced God on my hands and knees in the garden, not by going to church. My role as mother was to nurture. I had done it. I was doing it. I was a success in life. Isn't that what we are all looking for? Isn't that what it's all about?

Thanks to:

My mother, Selma Mikels Lofgren, for her editing and constant support and encouragement;

Isgo Lepejian, for a beautiful job of enlarging my photographs and encouraging me to complete the project;

Sue Taylor, for staying up three days and nights in a row typing my manuscript and for always believing in my work;

Paul Geoffrey, for listening to me for three days and nights and writing down the most interesting things I said, which became the basis for my text;

Tom Pope, for spending months helping me edit all my work, and for giving me his constant support;

Ruth E. Carsch, for her constant respect for me and my work and loads of good advice and friendship;

Monica Suder, for helping me look deeper into the project to find its real strengths;

Michel Monteaux, for believing in me and my work and laying out my first draft of the photographs;

Baron Wolman, Jerry Faires, Steven Cary, Elaine Mikels, and Ken Luboff for always being there for advice;

Susan Poe, for transcribing all the taped interviews even when she didn't have the right equipment;

Those who inspired me with their great ideas: Linda Wylie, Nancy Lees, Jane Alexander, Gay Dillingham, Edward Mast, Mel Lawrence, Peter Ledeboer, Richard Lees, David Wheeler, Bil Tate, Wavy Gravy, and Marcia Thelin;

Nion McEvoy and Bill LeBlond for realizing the timeliness of this body of work and editing it with great care and love!

Thanks also to all of you whose thoughts and words appear in this book, and to the I-Ching for guidance.

I love you all very much.

Backword

Seeing Lisa Law's sixties pix was a real blast from the past, a divine time warp, and a Be Here Then.

In 1979 I appeared at an eighties conference at the University of Wisconsin and stated, "The eighties are the sixties twenty years later, old feathers and a brand-new bird!"

These photos are like feathers honoring the past while encouraging future flight. These are the good ole days, and I have nostalgia for the future.

Keep on clickin' Lisa—just flap your arms and you can fly.

Wavy Gravy